PERSIAN DRAWINGS

DRAWINGS OF THE MASTERS

PERSIAN DRAWINGS

From the 14th through the 19th Century

Text by B. W. Robinson
Victoria & Albert Museum, London

LITTLE, BROWN AND COMPANY **LⓑB** BOSTON · TORONTO

A

LIBRARY OF CONGRESS CATALOGING IN PUBLICATION DATA

Robinson, Basil William.
 Persian drawings from the 14th through the 19th
century.

 Reprint of the ed. published by Shorewood Publishers,
New York, in series: Drawings of the masters.
 Bibliography: p.
 1. Drawings, Iranian. 2. Miniature paintings,
Iranian. I. Title. II. Series: Drawings of the
masters.
[NC321.R62 1976] 760'.0955 75-25673
ISBN 0-316-75142-1

Published simultaneously in Canada
by Little, Brown & Company (Canada) Limited

PRINTED IN THE UNITED STATES OF AMERICA

Contents

PERSIAN DRAWINGS

The best general introduction to Persian pictorial art was written twenty-five years ago by Mr. Eric Schroeder of the Fogg Art Museum, Harvard University. With his kind permission, I quote two passages:

There are many Persian paintings in our museums. The finest of them seem to me as beautiful as anything else those buildings contain. All kinds of people are attracted to them, and some are fascinated. I suspect that colour is what first attracts: real gold, real malachite, true ultramarine, unmixed vermilion are beautiful in themselves. What fascinates us afterwards is something very complex. There is, for instance, the loitering interest of narrative in childish form subtly organized in a very mature way, and a perfected draughtsmanship which yet has something in common with children's drawings and reminds us of something we can no longer see ourselves. A great wealth of detail not boring when explored, a certain tensity which so permeates the whole work as, for example, to make stiff figures look stiff with excitement, all these and other qualities undoubtedly affect us when we look at Persian paintings. Lovers of flowers have special reasons for lingering before them. They have all kinds of special and general interest and deserve their prestige.

• • •

Prince Muhammad Haidar Dughlat had imbibed the culture of the later Timurids, and his written criticism of recent and contemporary painters reveals as much as vocabulary can what such men as Prince

Husayn [see below, p. 20] demanded of art. His vocabulary includes: *Tarh* (design) which means diagram, intention; and "programme" comes nearer to it than our word "study." It was first laid down in "bones," according to the artist's *uslub*, style or method in the mechanical sense of straightforward efficiency. The virtues of a good *tarh* were that it should be both *muhkam*, tight, immovably fast and strong, like the ropes of a well-pitched tent, or a stable building, and *pukhta*, thoroughly cooked and ripened, with no part however small exempted from the consideration and adjustment which the most important parts received. The great and perhaps indefinable merit of design was *andam*, which means primarily body or limb, and which I understand as that combination of conventional proportion with grace and vitality which distinguishes the figures of Hellenistic statues, and the ladies of our theatrical choruses.... The completion of the painting was watched for other qualities. *Malahat*, the quality of a good melody, implies fluency and refinement of inflection; and *nazuki*, delicacy, slenderness, vulnerable softness, indicates a standard which would for example accept Falconet and reject Michelangelo. Firmness of stroke made a painting *khunuk*, desirably cool and mild, properly insipid, like cold water. True paintings should be *saf*, limpidly clear and clean, naked, sheer as a cliff. It is perhaps eminently the quality of a bald head, and *pardakht* the polish of a well-washed one. Two terms of disapproval indicate what the Timurids disliked: *durusht* means both big and coarse, so that they would have disliked Picasso, and *kham* means not only vain and pointless, but unsophisticated, and naif, so that they would have disliked primitives worthy of the name.

In this chance-bequeathed list of fourteen terms I find a precious monument to the integrity of those dead voluptuaries to whom we owe the most beautiful manuscript painting in the world. Where we flatter ourselves with a "sense of quality," they had "standards." They

praised the craftsman qualities in their men of genius, and knew as well how a good painting should look as an Oxford don knows how port should taste. With so excellent an example it will be our own fault if we make fools of ourselves before a Persian painting. Accepting monotony and extravagance as canons, let us proceed to judge the tension, the all-over thoroughness, and the seductive human grace of the design, the cold fluency of the execution, the high polish of the finishing. To eschew the sacred wafer of Genius is no hardship to a man who chews the beef-steak of honest performance."

Living as we do in an age whose arts so often make a point of reflecting the confusion, tension, and cruelty of the world around us, it is a joy and a relief to turn to the masterpieces of the Persian draughtsmen of the past. They take us into a calm, sunlit world where everything is bathed in a brilliant golden light; the men are all handsome and the girls are all beautiful; the tiled archways and parapets of the buildings resemble the finest jewelry; the rocks are like coral; the trees and plants are always in blossom; the fantastic little spirals of cloud floating in the gold or azure skies could never, one feels, cast a shadow on this fairy landscape. When it is necessary to portray such subjects as executions or battles, they are portrayed in such a way as not to distress us or harrow our feelings.

In nine cases out of ten Persian paintings and drawings illustrate some literary text; they are, in other words, "pictures with a story." To be effective, illustrations must be clear and easy to understand, and the Persian artists had various methods of achieving this end. For example, figures are disposed in different planes—as it were against a backcloth—in what is known as the "high horizon" convention, so that each can be seen separately. Darkness is never painted, but is simply indicated by showing the moon and stars, or lighted candles and lamps; very occasionally the ground is painted black, but otherwise the whole scene is rendered as if in broad daylight so that we can see

clearly whatever is going on. It will be gathered from this that Persian art is highly conventionalized—human figures, animals, and natural objects are, in effect, portrayed as idealized symbols; but everything is done to make the action and the point of the story as clear as possible.

Apart from effectively illustrating the narrative in hand, the chief aim of the Persian artists was to give pleasure. Indeed, it would be foolish, when looking at a Persian painting or drawing, to ask the sort of question that springs to mind when we contemplate Western pictorial art such as: "What is the artist's message for us?" The Persian artist's message is simple and invariable: "This is the most beautiful and effective illustration I can make to this story; I hope you will like it." This humble desire to give pleasure to others comes as rather a surprise and a relief after the self-conscious parading of their own ideas and personalities indulged in by so many painters in Europe and America. Let us then forget, if we can, the high-flown and sophisticated jargon of the art critics and try to look at these elaborate yet uncomplicated works with the simple eyes of children (their appeal to children, incidentally, is strong and immediate), delighting in their beauty of line and richness of color, and enjoying the strange stories they tell. Their beauties are all on the surface; no spiritual message or Freudian symbolism lurks beneath their exquisite forms and colors.

Wherein, then, lies the essential charm of the Persian miniature? To a great extent, surely, in its perfectionism. In the best examples—excluding second-rate hackwork from our present consideration—every detail is as perfect as human skill can make it. The initial impact is sometimes almost breathtaking. We may take a strong glass to the renderings of brickwork and tiles on buildings, patterns of carpets, clumps of flowers in the foreground or stately plane trees or feathery tamarisks on the horizon, or details of armor, weapons, and saddlery, and they will still appear perfect under its ruthless magnification. And this perfection of technique demanded a perfection of materials: the smooth paper with its warm, creamy tones, the rich and costly

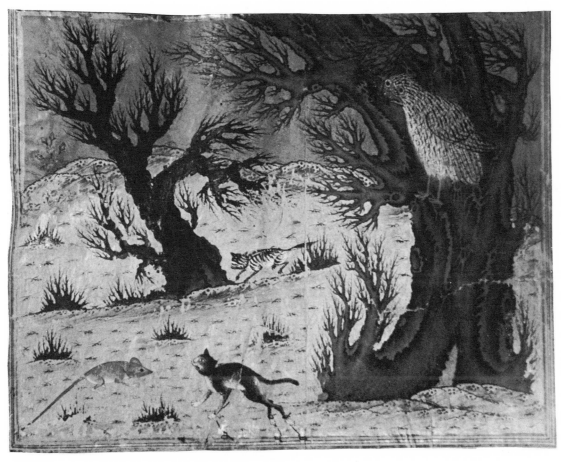

Figure 1

ANONYMOUS, Herat School · *The Owl, the Cat, the Mouse, and the Weasel, ca. 1470* · opaque colors and gold, 4⅜ x 5⅞ inches · Gulistan Palace Library, Tehran

pigments, and the lavish gold. Because of these materials, the miniatures were expensive to produce, so it is not surprising that the best Persian artists worked under the patronage of ruling princes and their families.

But all these excellencies were dominated and fused by the master-hand of the artist himself. Just as the discipline of brush-written characters gave to Chinese and Japanese draughtsmen their effortless mastery, so the elegant runs, curves, and flourishes of the *nasta'liq* script inspired the faultless line of the Persian artists whose subtle changes of emphasis give the effect of solidity without the necessity for modelling in the Western sense. In fact, the true Persian style of drawing and the *nasta'liq* script were twins, born together at the end of the fourteenth century. The masterpieces of the preceding Mongol period were larger, stiffer, and more monumental, reflecting the qualities of the upright and angular *naskhi* script then in use, but the true Persian style grew up with the conqueror Timur (Tamerlane), and the early Timurid period saw its first flowering.

A. THE METROPOLITAN STYLE

I. TIMURID PERIOD: EARLY DEVELOPMENTS, 1370-1415 (PLATES 1-11). Strangely enough it is under the Muzaffarid dynasty (1353–93) at Shiraz—a minor dynasty in a provincial city—that we find the first dated examples of Persian book illustrations (Pl. 1) which, though comparatively simple and unsophisticated, are yet close kin to the magnificent works of the fifteenth- and sixteenth-century artists. The paintings produced at the same city under the Inju dynasty (driven out by the Muzaffarids in 1353) had been of a totally different character—crude, rather childish, small, and crowded, with the figures usually arranged in a row along the base of the miniature. Less than twenty years separate the last dated Inju work (1352) from the earliest Muzaffarid (1370), yet in the latter we find the "high horizon" already used with confidence to give space and depth to the composition, and the figures smaller in proportion

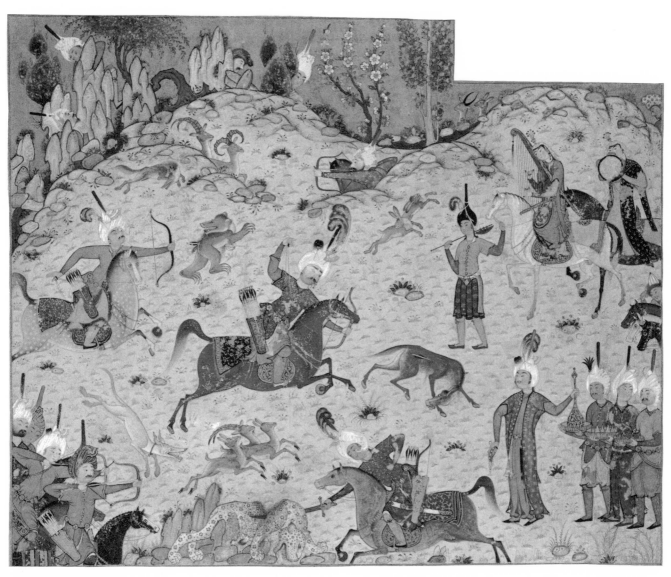

Figure 2

Probably by SULTAN MUHAMMAD · *Bahram Gur Hunting*, 1527 · opaque colors and gold, 10⅜ x 14¾ inches · Bibliothèque
Nationale, Paris

to the whole, drawn with delicacy, tall and slim after the rough, stocky characters of the Inju paintings. How did this fundamental and revolutionary change come about? We cannot be sure, but it seems likely to have been imported by the Muzaffarids from Baghdad. For, in one of the very few literary documents on Persian painting to have come down to us, we are told by Dust Muhammad, himself a painter of standing in the mid-sixteenth century, that in the reign of Abu Sa'id (the Mongol ruler of Persia, 1317-34) "the master Ahmad Musa, who learned the art from his father, unveiled the face of painting, and invented the kind of painting which is current at the present time." And Ahmad Musa's pupil, Shams al-Din, worked at Baghdad under Shaykh Uways, the Jalayrid ruler (1356–74).

The last crumbling remains of Mongol rule were swept away by Timur during the last quarter of the fourteenth century. One of the dynasties that fell before him was that of the Jalayrids, who had been in power at Baghdad and Tabriz. The last ruler of this dynasty, Sultan Ahmad, was a notable patron of the arts, and in his time the new style had been brought to perfection. Two manuscripts fortunately survive to show us the excellent work done under his patronage. The first, illustrated with nine miniatures by Junayd, a pupil of Shams al-Din, was completed in 1396 (Pl. 4); the other is a collection of poems by Sultan Ahmad himself, dating from 1402, some of the margins being decorated with exquisite, lightly tinted drawings (Pls. 2, 3). Very few line drawings have survived from this early period, causing some writers to dismiss the marginal decorations of Sultan Ahmad's *Diwan* as later additions, but their style is absolutely right for the period. Sultan Ahmad is said to have been a gifted amateur draughtsman, and it is not, perhaps, impossible that he himself added these informal embellishments to the margins of his own poems.

After the death of Sultan Ahmad it seems that his court painters took service with the Timurid conquerors, becoming the founders of an uninterrupted line of metropolitan court painting beginning, as we have seen, at Baghdad under the Jalayrids, and stretching thence to Shiraz (*ca.* 1397–1415) and

Herat (1415–1502) under the Timurid princes, and continuing unbroken to the Safawid capitals of Tabriz (1502–48), Qazwin (1548–98), and Isfahan (1598–1722). This line we shall now follow.

During the first twenty years of Timurid rule (*ca.* 1395–1415), the style which Junayd and his fellows brought to perfection at Baghdad is found, with only very slight modifications, in the illustration of a number of manuscripts, the most important of which can be associated with Shiraz. The collection of epics (Pls. 5, 8) is the earliest of these; the style of its illuminations proclaims its Shiraz origin, and it may perhaps have been executed for the cultivated but wayward prince, Iskandar Sultan, then aged thirteen or fourteen, who held his court at Shiraz between the death of his father in 1394 and his appointment to the province of Farghana in 1399. After a number of vicissitudes he returned to Shiraz as governor in 1409, remaining until his downfall (as a result of persistent treachery against his uncle, Shah Rukh) in 1415. To this second Shiraz period belong the two other manuscripts that stand out in the early Timurid period, the *Anthology* of 1410 in the Gulbenkian Foundation, Lisbon, and the *Miscellany* of 1410–11 in the British Museum (Pls. 9, 10), as well as some scattered fragments of other volumes from the prince's library (Pl. 11). These manuscripts contain a body of miniatures which served as prototypes and models to three generations of Persian artists, and constitute a lasting monument to the exquisite taste and inspired patronage of the ill-starred Iskandar Sultan. The only other really outstanding manuscript from this earliest phase of the Timurid dominion was produced at Tabriz, for whom we do not know. Its illustrations, with their graceful and rather attenuated figures, are nearer to the work of Junayd at Baghdad than to that of Iskandar Sultan's artists at Shiraz, and are of superb quality (Pls. 6, 7).

II. THE ACADEMY OF BAYSUNGHUR, 1415–33 (PLATES 12–16, 18). Soon after the fall of Iskandar Sultan, the northeastern city of Herat became the chief center of the metropolitan style. Between 1415 and 1433 it was the seat of Baysunghur Mirza, son of Shah Rukh, one of the most enlightened and munificent

patrons of painting and the arts of the book in the history of the Near East. He brought together the best artists from every part of Persia (including, no doubt, some of those who had worked for his cousin, Iskandar Sultan, at Shiraz) to form an academy of book production, whence issued between about 1420 and 1433 a group of illustrated manuscripts of unrivalled quality and magnificence. Baysunghur obviously took a keen personal interest in the work of his artists, calligraphers, and illuminators, who were under the supervision of Ja'far of Tabriz, a past master of the *nasta'liq* script and copyist of the great *Shahnama* of 1430. During the short period of the young prince's patronage the style of drawing and painting that had been practiced under Sultan Ahmad Jalayr and Iskandar Sultan was developed, polished, and standardized.

III. THE HERAT SCHOOL, 1433–80 (PLATES 17, 19–23). But between the death of Baysunghur in 1433, and the accession of Sultan Husayn Mirza to the throne of Herat in 1469, this style became somewhat rigid and academic. Nevertheless, technical quality remained as high as ever, and the best miniatures of the period show that Baysunghur's exacting standards were being maintained, albeit with some loss of vigor and originality. The Tehran book of fables, *Kalila wa Dimna* (Fig. 1), one of the finest of all Timurid manuscripts, has usually been considered to date from near the beginning of the fifteenth century (it has lost its colophon), but for reasons fully set forth elsewhere (see *Oriental Art,* Summer, 1958) it seems best to place it in the first years of Sultan Husayn's rule at Herat, along with such other manuscripts as the Chester Beatty Tabari (Pl. 20).

IV. THE SCHOOL OF BIHZAD, 1480–1505 (PLATES 24-31). Bihzad, the greatest of all Persian painters, made his appearance at the court of Sultan Husayn about 1480, and found himself amidst one of the most cultivated societies the East has ever seen. The Prince himself was an accomplished literary man, and, although given to the bottle and other diversions of a more or less dissipated

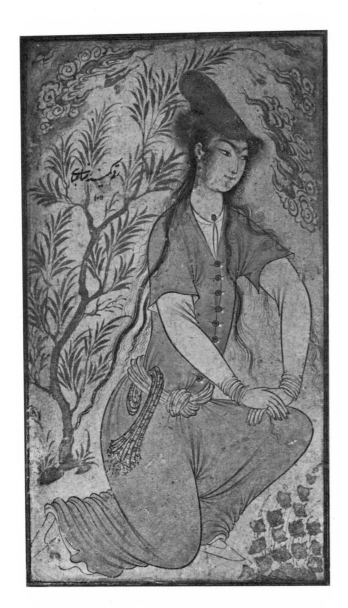

Figure 3

RIZA-I'ABBASI
Girl in a Fur-Trimmed Hat, 1602—3
paper
5-13/16 x 3-5/16 inches
The Hermitage, Leningrad

nature, such as ram-fighting, contrived to be a munificent patron of literature and the arts. The scholar-statesman Mir 'Alishir (the Prince's vizier), the poet Jami, and the historian Khwandamir—the leading writers of their time— were now joined by the most talented of artists. Bihzad immediately injected a new vitality into the court style. Many of his innovations tended towards naturalism; his human figures are much more individualized than those of his predecessors, and some have the appearance of portraits; some of the stiffer conventions for trees are replaced by more flexible and naturalistic representations; and rocks are rendered in soft, delicately shaded tones, no longer resembling masses of coral or sponge. His drawing is always firm, fluent, and lively.

V. SAFAWID PERIOD: THE TABRIZ STYLE, 1505–50 (PLATES 32–38). Bihzad's employment of Shah Isma'il Safawi after the foundation of the new dynasty at the beginning of the sixteenth century when he established his capital at Tabriz, ensured the continuity of the metropolitan style. The only difference between the earliest Safawid and the latest Timurid court painting is a new detail of costume, the characteristic Safawid turban bound in twelve folds (representing the Twelve Imams) round a cap surmounted by a slender baton, usually colored red. This turban remained in vogue until shortly after the middle of the century, but is occasionally encountered in later work.

During Bihzad's old age, between about 1520 and 1530, the court style was enlarging its scale and becoming increasingly sumptuous. Shah Tahmasp (1524–76), in the earlier part of his reign, was an enthusiastic patron of painting, and the copies made for him of the *Shahnama* (*ca.* 1525–30) and of the *Khamsa* of Nizami (1539–43, Pl. 35) are perhaps the most lavish and luxurious Persian manuscripts ever produced. But some of the freshness and virility of Bizhad was lost and, except in the hands of the greatest masters like Sultan Muhammad (Fig. 2; Pl. 34), the court style of Tabriz, however magnificent, sometimes appears insipid and overdone in comparison with the best work of the previous century. Other leading artists who worked for Shah

Tahmasp and collaborated in the splendid manuscripts made for him were Mirak (to be distinguished from Mirak of Khurasan, the teacher of Bihzad), Mirza 'Ali (Pls. 37, 38), Mir Sayyid 'Ali (Pl. 36), and Muzaffar 'Ali (Pl. 35).

VI. THE QAZWIN STYLE, 1550–90 (PLATES 39–51). In 1548 the capital was moved from Tabriz (which had been found to be a little too vulnerable to Turkish attacks) to Qazwin, and soon after this a change began to take place in the metropolitan style. The transition can be seen in a magnificent manuscript of Jami's poems executed between 1556 and 1565 for Prince Ibrahim Mirza, nephew of Shah Tahmasp and grandson of Shah Isma'il, the founder of the dynasty (Pls. 45, 48). Developments that can be seen in the later miniatures in this manuscript include a growing emphasis on graceful, sinuous lines, and slimmer and more attenuated figures with longer necks and rounder faces. By about 1575 this style had become associated with the name of the artist Muhammadi (Pls. 40, 46), who may have been a son of Sultan Muhammad, the leading court painter of Shah Tahmasp's earlier years. It may be, indeed, that one or two of the later miniatures in the Jami manuscript represent Muhammadi's early work; he was a native of Khurasan, and it was at Mashhad in that province that the manuscript was produced. Siyawush the Georgian (Pls. 42, 43) and Sadiq were the other two most prominent court artists of the later sixteenth century.

It was at this time also that separate drawings and miniatures began to appear in increasing numbers (Pls. 39–42, 44, 46, 47, 50, 51). Artists could no longer live on royal patronage: in his later years Tahmasp became a religious bigot and turned his back on painting; his successor, Isma'il II (1576–77), though a cultivated man, was a fratricide and a debauchee with Sunni leanings; and the next king, Muhammad Khudabanda (1577–1582), was a nonentity. During this period, then, artists depended increasingly on commissions from private citizens, and as these could seldom afford an illustrated mansucript *de luxe* they contented themselves with single miniatures and drawings, often of very high quality, which were generally kept in albums.

VII. THE ISFAHAN STYLE, 1590–1722 (PLATES 52–69). Shah 'Abbas the Great fought his way to the throne in 1582, and in 1598 the capital was transferred from Qazwin to Isfahan, which thus provides a convenient name for the new style then coming into vogue. The artist mainly responsible for its formation was Aqa Riza. From his hand have survived a number of single figure studies, often uncolored or only lightly tinted (Pls. 54, 60), and some manuscript illustrations, notably in a fragmentary *Shahnama* of great magnificence in the Chester Beatty Library (Pl. 53). All these works can be dated to about the last decade of the sixteenth century. Aqa Riza was a superb draughtsman who developed the calligraphic line, already noticeable in some mid-sixteenth century drawings, in order to suggest volume and drapery. The human figures and faces filled out somewhat after the elegant slimness of Muhammadi. In his fully colored work Aqa Riza maintained the brilliant tones and contrasts of the earlier Safawid court style.

We learn from the historian Iskandar Munshi that by about 1615 Aqa Riza had given up painting and taken to low company. But it was just at about this time that the artists Riza-i 'Abbasi was coming into prominence. He is identified with Aqa Riza by some authorities, and the difficult question of whether they were one artist or two is not yet finally settled. The earliest dated work bearing Riza-i 'Abbasi's signature is a tinted drawing of 1603 (Fig. 3) which is very close indeed to some of the drawings attributed to Aqa Riza. However, in his more mature productions (Pls. 58, 61, 64, 65), which set the style of Persian drawing and painting for the rest of the seventeenth century, Riza-i 'Abbasi departed considerably, both in line and color, from this earlier style. The postures of his figures became overelegant and affected, the faces coarsened, and the treatment of drapery and other details was hard and set. He completely revolutionized the color scheme, replacing the old pure pigments with purples, yellows, and browns. Most of his work, of which a great deal has survived, is in the form of album pictures and sketches. But he did some manuscript illustration, notably in a copy of the *Khusraw and Shirin* of Nizami; one of these miniatures bears a date corresponding to 1632 (Pl. 58).

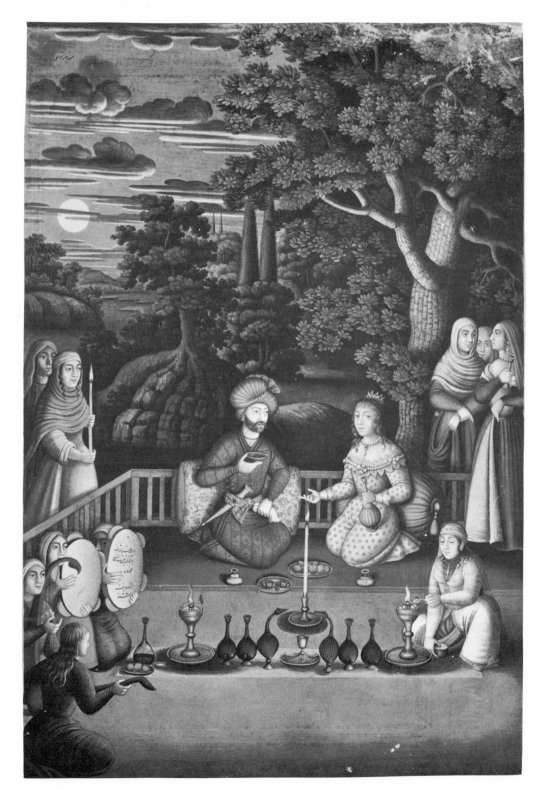

Figure 4
MUHAMMAD ZAMAN
Bahram Gur and the Indian Princess
Feasting by Night,
1675
14½ x 10 inches
British Museum, London

By the middle of the century Riza-i 'Abbasi's style was being carried on by such artists as Afzal al-Husayni (Pl. 68), Muhammad Qasim (Pls. 62, 63), Muhammad Yusuf (Pl. 56), and Muhammad 'Ali (Pl. 66), in whose hands it became, if anything, even more mannered. The most original follower of Riza-i 'Abbasi was Mu'in, who was still working at the beginning of the eighteenth century, and who left, besides the usual figure studies and sketches, a number of *Shahnama* illustrations (Pls. 67, 69). The style lingered on in various debased forms during the first half of the eighteenth century, even after the sack of Isfahan by the Afghans and the fall of the Safawid dynasty in 1722.

B. LOCAL STYLES, 1415–1600

I. THE TIMURID STYLE OF SHIRAZ, 1415–55 (PLATES 70–75). We must now turn back to the fifteenth century and examine the styles of painting that flourished in various places independently of the metropolitan court style. When Prince Baysunghur was established at Herat in 1415, his brother Ibrahim Sultan was governor at Shiraz under their father Shah Rukh. Ibrahim was a bibliophile like his brother, and assembled about him such artists as he could muster. The style they practiced seem to have been a blend of the Muzaffarid style of the previous century with elements of the early Timurid court style. It is bolder and somewhat rougher than the academic style of Herat, its figures larger in proportion to the compositions, sometimes awkward, but often endowed with astonishing vigor. Decorative elements in the miniatures, such as tilework on buildings and carpet designs, are more summarily rendered than in the works of Baysunghur's artists, the color schemes are more subdued, and the quality of the pigments used is not so high. The style continued after Ibrahim's death in 1435, but lost some of its early strength, and Shiraz work of 1440–50 (Pls. 73, 75) is usually on a smaller scale than the earlier examples. However, the monumental miniatures in a *Shahnama* of 1444 in the Bibliothèque Nationale, Paris, are conspicuous exceptions to these tendencies.

II. TIMURID PROVINCIAL STYLES, *ca.* 1430–80 (PLATES 76–79). It may be convenient at this point to notice briefly the outlying provincial styles of the Timurid period, most of which can be dated between about 1430 and 1480. The three main styles during the fifteenth century were the metropolitan court style centered at Herat from about 1415, the Shiraz-Timurid style of 1415–55, and the Turkman style that succeeded the latter (see below). But a number of Timurid drawings and miniatures are encountered that cannot be affiliated to any of these three schools. A very few of these can be located by statements in the colophons or dedicatory pages of the manuscripts concerned—a *Shahnama,* for example, copied in 1446 for an obscure local ruler in Mazandaran, and an *Anthology* made for the Prince of Shirwan in 1468. Provincial work in general is naïve and usually inferior in execution to that issuing from the main centers of production, but it is often lively and highly individual. It may perhaps be suggested that northern provincial work is stronger and somewhat cruder than southern, and tends to cling to some of the idosyncrasies of the Mongol period (Pl. 76). The southern style is delicate in drawing and has, generally, a light touch in such details as rocks and vegetation. Most identifiable southern provincial miniatures seem to have been executed at Shiraz or Isfahan (Pl. 79), and known examples are contemporary with the Turkman style; indeed, miniatures of both styles occur together in several manuscripts, for example the Chester Beatty Nizami of 1481 (Pl. 77).

III. THE TURKMAN STYLE, *ca.* 1450–1510 (PLATES 80–87). In 1452 Shiraz was taken by the Turkmans and by about 1460 they had conquered the whole of Persia except Khurasan, which remained under Timurid rule, and the Caspian provinces. Within less than a decade the Shiraz-Timurid style of painting had disappeared. The style that ousted it was to some extent a throwback to the Mongol period. Miniatures tended once more towards the horizontal, landscapes and decorative elements were much simplified and highly conventionalized, and the human figures became comparatively squat

with big heads and round faces. Although the earliest examples of the Turk-man style may date from the 1430's, it is most often found in manuscripts of the second half (and especially the last quarter) of the fifteenth century. It seems to have come in with the Turkman conquerors and probably originated in the north or northwest, comparable styles being found in Mazandaran and Shirwan during the middle years of the century. It may also have derived partly from a simplified form of the early Timurid style practiced at Herat under Shah Rukh just before the establishment of Prince Baysunghur's academy. Shiraz was its main center, but it was no doubt practiced in other cities under the Turkman dominion. It cannot, of course, compare in richness and elegance with the work being produced at the same time by Bihzad and his school at Herat, but it has a simple charm of its own.

IV. THE SAFAWID STYLE OF SHIRAZ, 1510–1600 (PLATES 88–93). Between about 1510 and 1525 the Turkman style at Shiraz was undergoing a number of modifications under the influence of the rapidly developing court style of Tabriz. The Safawid "baton" turban, of course, appeared, the baton being rather thick in the earliest examples. The human figures gradually lost their Turkman squatness, landscape features were brought more into line with the canons of the court style, and the miniatures themselves expanded upwards once more and became more spacious (Pls. 85, 87, 88, 90). But this Shiraz-Safawid style remained simpler and less ambitious than the contemporary styles of Tabriz and Qazwin. Like its progenitor, the Turkman style, it seems to have had more numerous but less affluent patrons than the metropolitan style, and gives an impression of "utility." Surviving examples are, in fact, more numerous than those of any other style of Persian painting.

Throughout the sixteenth century this style maintained its distinctive character, though the Shiraz artists followed the lead of the capital in the slightly modified figure drawing we have already noticed under the Qazwin style. But, in comparison with the metropolitan style, Shiraz painting remained flat in appearance, pale in tone, and sometimes provincial in character, and seems to have merged into the court style of Isfahan soon after 1600.

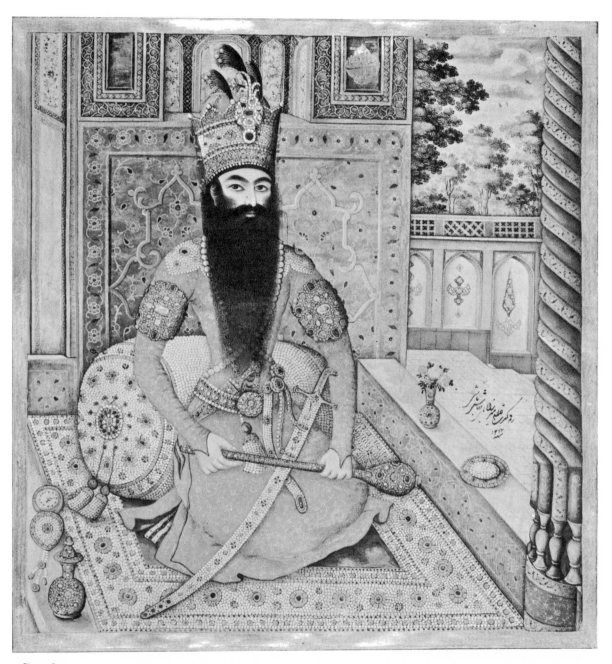

Figure 5

MIRZA BABA • *Portrait of Fath 'Ali Shah*, 1802 • opaque colors and gold, 16¾ x 11½ inches • Windsor Castle,
Royal Library

V. THE BUKHARA STYLE, *ca.* 1500–1600 (PLATES 94, 96). The other city that maintained a separate artistic character during the sixteenth century was Bukhara, seat of the Uzbek Shaybanid princes. In the course of a series of raids across the River Oxus in the early years of the century, the warlike Uzbeks captured Herat on two occasions, transporting a number of artists and craftsmen back with them to Transoxiana. The imported Herati artists brought with them the rich colors and meticulous execution of Bihzad's style, and until about 1525 painting produced at Bukhara is almost indistinguishable from contemporary work done at Herat or Tabriz, except by the absence of the Safawid baton from the turbans (Pl. 96). Even in the middle years of the century a very high standard was usually maintained (Pl. 94).

Soon after this, however, there are signs of decay, probably due to the fact that the imported Persian artists were by then either dying off or going into retirement, and the work was being done by their less skilled Uzbek pupils. The colors retain the pure brilliance of fifteenth-century Herat work, but the drawing becomes increasingly lifeless and stereotyped, and the standard of execution in many cases leaves much to be desired. Two manuscripts of Jami's poems in the Bodleian Library, Oxford, show us the state of Bukhara painting towards the end of Shaybanid sovereignty. The colors are still good but the drawing is often inept, and the landscape is arbitrarily covered with meaningless patterns of tiles and scrollwork. Soon after this the Bukhara style disappeared or, possibly, merged into the Mughal style of Delhi.

C. EUROPEAN INFLUENCE, 1675–1896

European pictures were certainly known in Persia during the reign of Shah 'Abbas the Great, and an occasional Western touch may be found in miniatures of the period. Portraits of young men in European costume are not uncommon. But the wholesale Europeanization of Persian painting and drawing dates from the return of the artist Muhammad Zaman from a period of study in Italy, about 1670. His best work is seen in the miniatures he added

to two royal manuscripts already referred to, the Nizami of Shah Tahmasp in the British Museum (Fig. 4) and the *Shahnama* of Shah 'Abbas the Great in the Chester Beatty Library. His technique is impeccable, but the blend of East and West is not an unqualified success.

However, the style he introduced rapidly became fashionable at court, and by the time of Nadir Shah (1735–47), if not earlier, it had begun to take the form of large portraits in oils in the European manner. Very few manuscript illustrations or drawings have survived from the eighteenth century, and those that have are very bad. Small-scale work is to be found on the innumerable lacquered pen boxes, mirror cases, and book covers that have come down to us from this and the later Qajar period, and these often display a high degree of technical skill (Pls. 95, 98, 99).

Politically the eighteenth century was a period of the utmost confusion. When Persia settled down once more to comparative peace and unity under Fath 'Ali Shah Qajar (1796–1834) there was something of a renaissance in painting. The king himself kept a host of court artists busy on numerous life-size portraits of himself, his large family, and his enormous establishment of singing- and dancing-girls and other ladies devoted to his entertainment. Among these artists, Mirza Baba (Fig. 5) and Mihr 'Ali (Pl. 99) were perhaps the most talented, the latter's large oil portraits of his royal master being among the best paintings produced under the Qajar dynasty.

Illustrated manuscripts appeared once more in considerable numbers, but, as with the oil paintings, with the exception of those executed for Fath 'Ali Shah himself, or for members of his family, the quality is not usually high. The old opaque, enamel-like pigments had been abandoned for thinner watercolors, and the illustrations were often made up of stereotyped groups of figures and landscape features rearranged in various ways to form different compositions.

By the middle of the nineteenth century, excellent portraits in miniature technique were being produced by Abu'l-Hasan Ghaffari and his followers (Pls. 97, 100) but, in general, drawing and painting in Persia were at a low

ebb. Later on we find a number of imitations of earlier styles, as in a charming manuscript of Khaqani, dated 1888, in Cambridge University Library, but they lack the vigor and originality of earlier work, and many of them, it is to be feared, must be classed as deliberate forgeries.

Such was the state of Persian painting at the death of Nasr al-Din Shah in 1896, the end of the *ancien régime*. Since World War II, a revival has been in progress. Examples of the work of living miniature painters, shown in London in 1948, displayed a technique of undiminished perfection, but the majority were simply imitations of the Safawid styles of Tabriz and Isfahan, and some were marred by the introduction of incongruous European features, such as the diminution in size of figures in the distance. However, some magnificent drawings have since been produced, in particular by a latter-day namesake of the great Bihzad and by Rustam Shirazi of Isfahan. The works of both these artists are in the pure Persian tradition, but vital and original, and we may hope that from them and others like them the art will receive the fresh direction and inspiration it needs.

B. W. ROBINSON

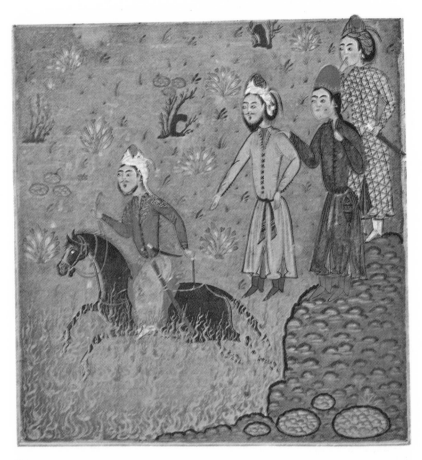

Plate 1

ANONYMOUS, Early Timurid • *The Fire-Ordeal of Siyawush*, 1370 • watercolor
with gold on paper, 4⅜ x 4⅜ inches • Topkapi Sarayi Library, Istanbul

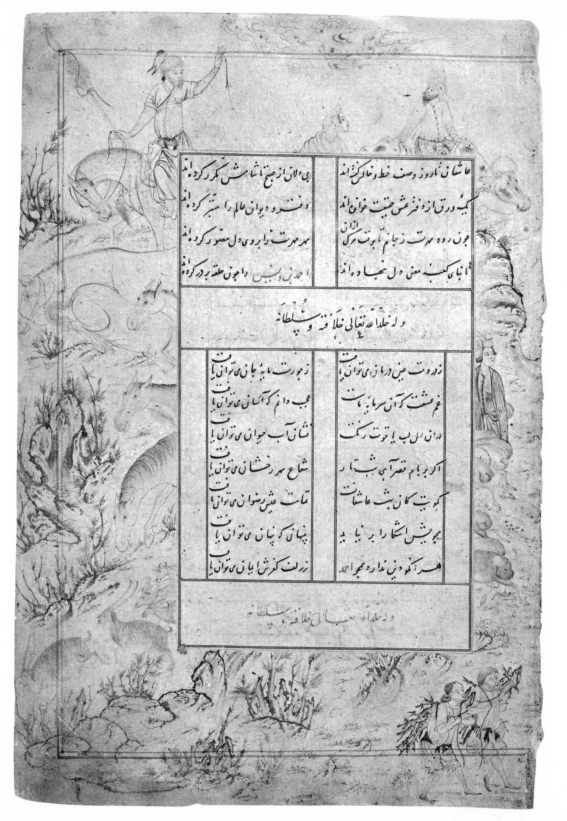

Plate 2

ANONYMOUS, Early Timurid
Camp Scene (marginal draw-
ing), 1402
ink and slight tint on
paper, 11⅝ x 8 inches
Courtesy of the Smithsonian
Institution, Freer Gallery of Art,
Washington, D.C.

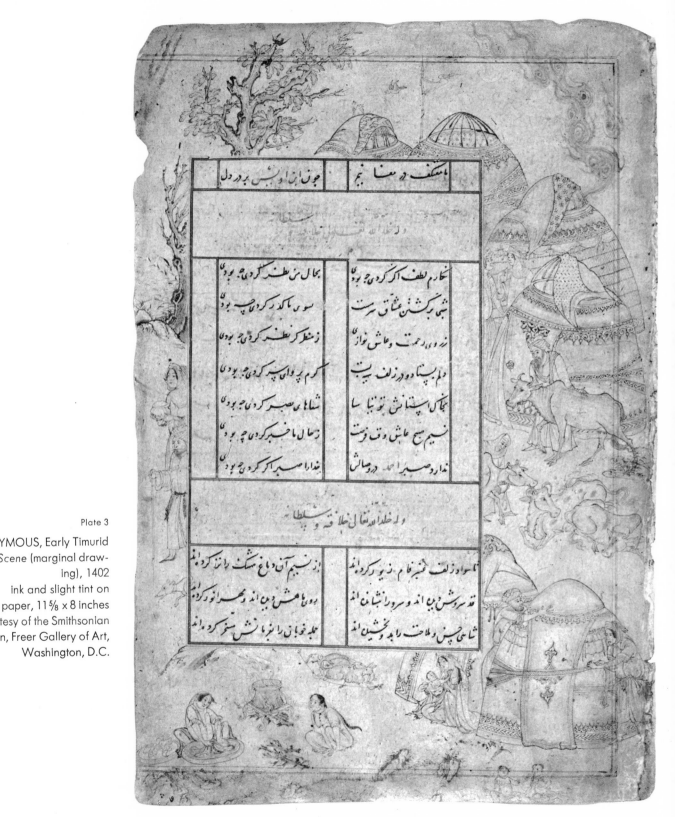

Plate 3

ANONYMOUS, Early Timurid
Camp Scene (marginal draw-
ing), 1402
ink and slight tint on
paper, 11⅝ x 8 inches
Courtesy of the Smithsonian
Institution, Freer Gallery of Art,
Washington, D.C.

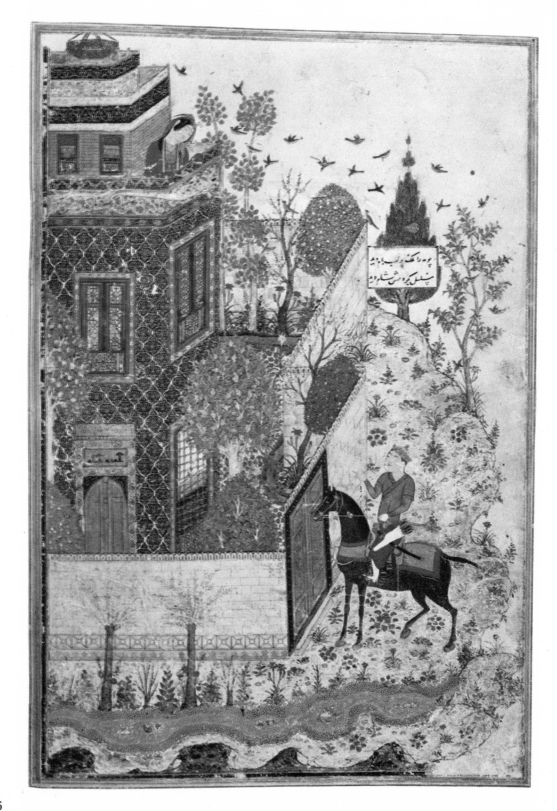

Plate 4

JUNAYD
Humay at the Castle of
Humayun, 1396
12¾ x 9¼ inches
British Museum, London

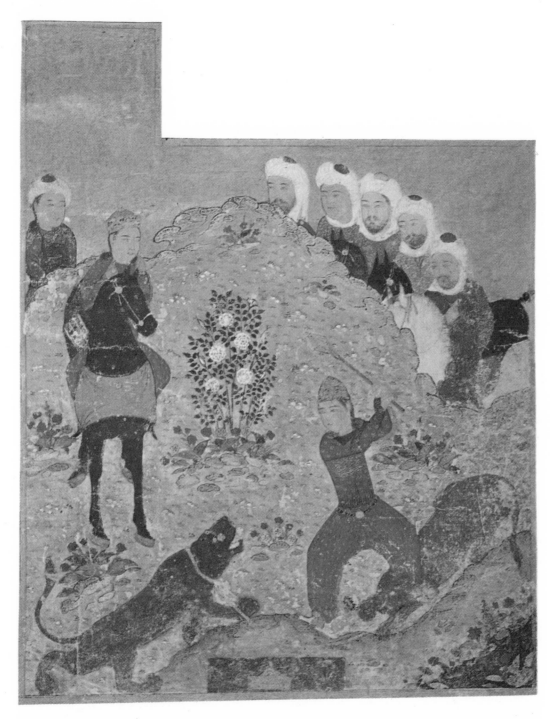

Plate 5

ANONYMOUS, Early Timurid • *Bahram Gur and the Lions*, 1397 • opaque colors and gold,
7-3/16 x 5⅝ inches • The Chester Beatty Library, Dublin

وکرسک آمدایں مسکنوی خصا
بدان صورت که دل دادنرکوا
زیش کن کوه خودرا کرم کرده
فضارا اسیشن اندرراه ست
ش تنها زنرو دیک غلامان
جطاو یے عنای بارسته
بان لعل را آتشنه می سفت

جوخضه اسبک ارد سوی صحرا
خبرمی داد زالهام خدا
سوی ارمن زمین را نرم کرده
بدان منزل کو آنہ موی می ست
سوی ان غرسنزارا ده خرامان
نظروی بولک کوثر نشسته
دران آتشنی استه می کفت
کران بت جان مں بودی جوہو
وران ابسب ان نرو دجہ بود
نود آک که ان شبرک وان مه
برج او فرو خوایہ شد ارراه

دراں سجد کا او خواید باژر
جوکنت این قصه برخون دف جوان
زبهم شہ می شد دل پراژرد
غلامان را برمود استادن
طوابے زد دران برہ وزه نشن

بنتر روی را قصری سیارید
سلیمان وار با جمعی برنزا د
د منزل برابک منزل می کرد
سنوران را علفها برنها دن
میان کشنی بی دید روشن

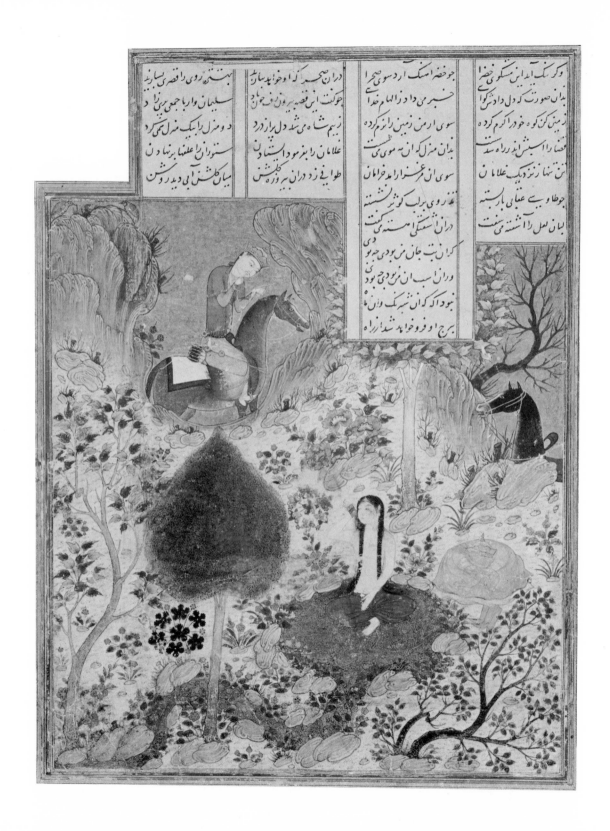

Plate 6

ANONYMOUS, Early Timurid
*The Sculptor Farhad before
Queen Shirin,* ca. 1400–10
color with gold and silver on paper
6-7/16 x 6 inches
Courtesy of the Smithsonian
Institution, Freer Gallery of Art,
Washington, D. C.

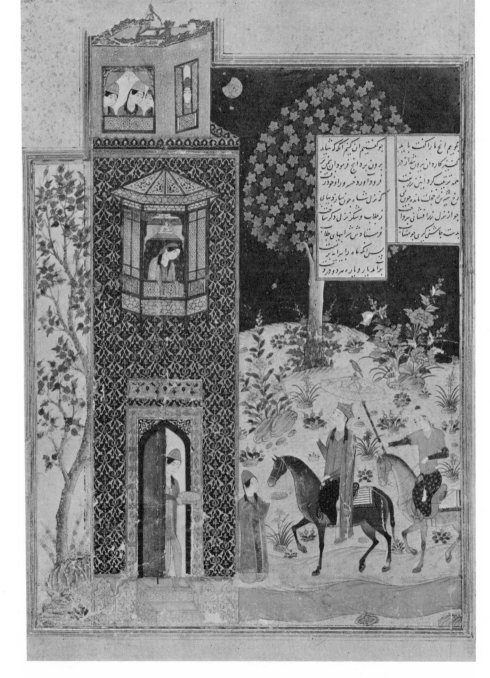

Plate 7

ANONYMOUS, Early Timurid
Khusraw at Shirin's Palace,
ca. 1400–10
opaque colors and gold on paper
10⅛ x 7¼ inches
Courtesy of the Smithsonian
Institution, Freer Galley of Art,
Washington, D. C.

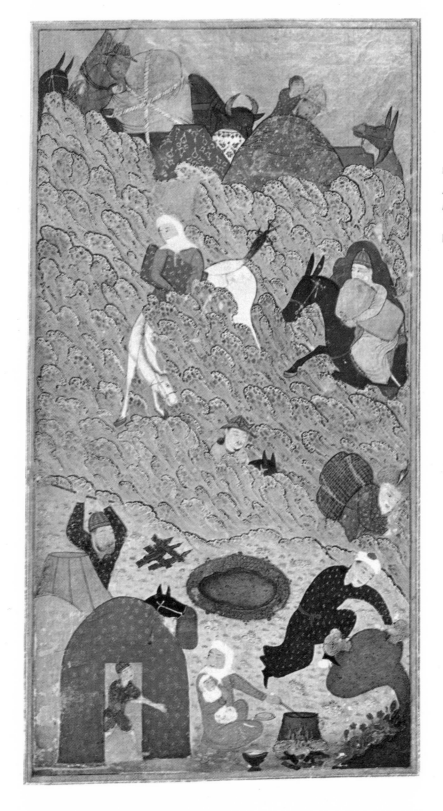

Plate 8

ANONYMOUS, Early Timurid
Pastoral Life of the Mongols, 1397
10 x 6½ inches
British Museum, London

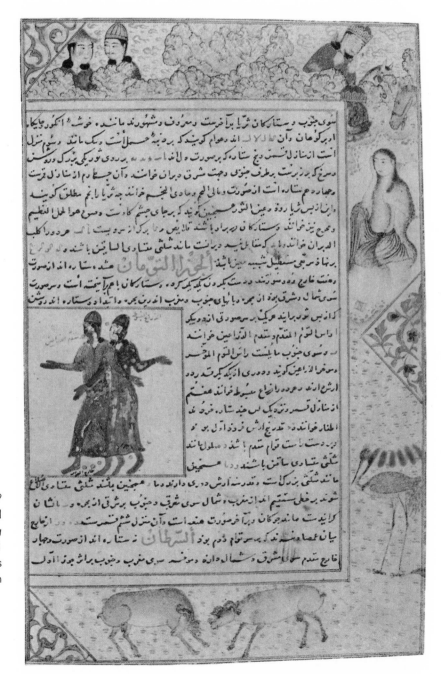

Plate 9
ANONYMOUS, Early Timurid
Khusraw Spies Shirin Bathing
(marginal drawing), 1411
7¼ x 5 inches
British Museum, London

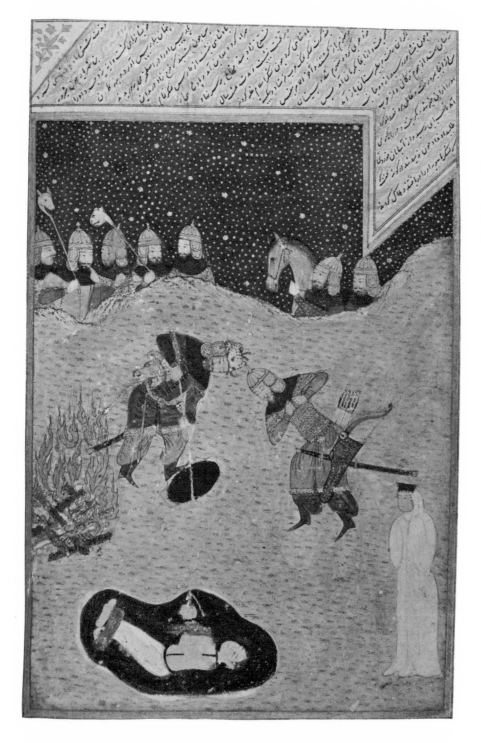

Plate 10

ANONYMOUS, Early Timurid
Bizhan Rescued by Rustam, 1411
7¼ x 5 inches
British Museum, London

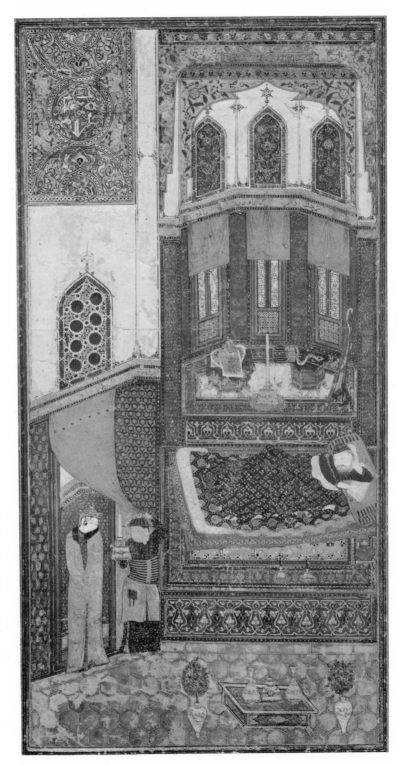

Plate 11
ANONYMOUS, Early Timurid
*Tahmina Comes to Rustam's
Chamber*, ca. 1410
gouache on paper
8¼ x 4⅛ inches
Courtesy of the Fogg Art Museum,
Harvard University

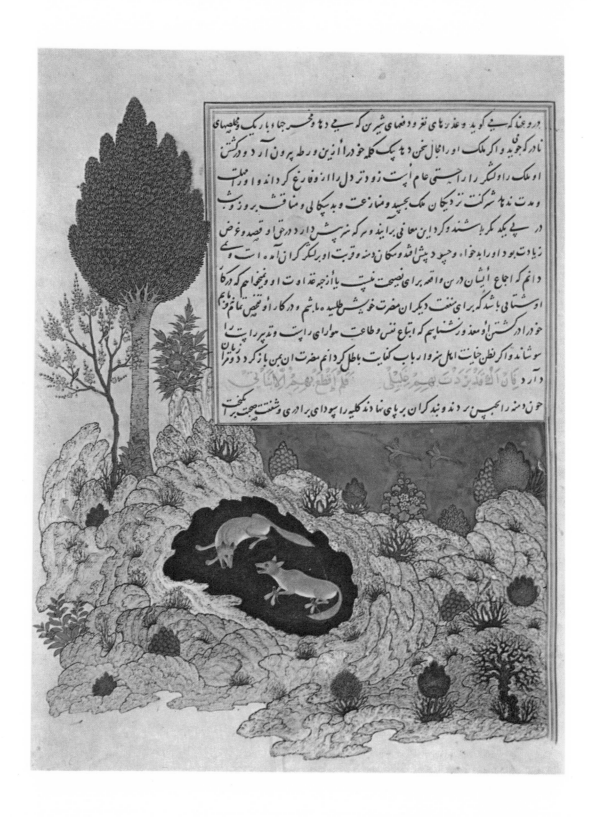

Plate 12

Academy of Baysunghur
*The Jackal Kalila Visiting His Friend
Dimna in Prison*, 1430
watercolor on paper
9½ x 7⅛ inches
Topkapi Sarayi Library,
Istanbul

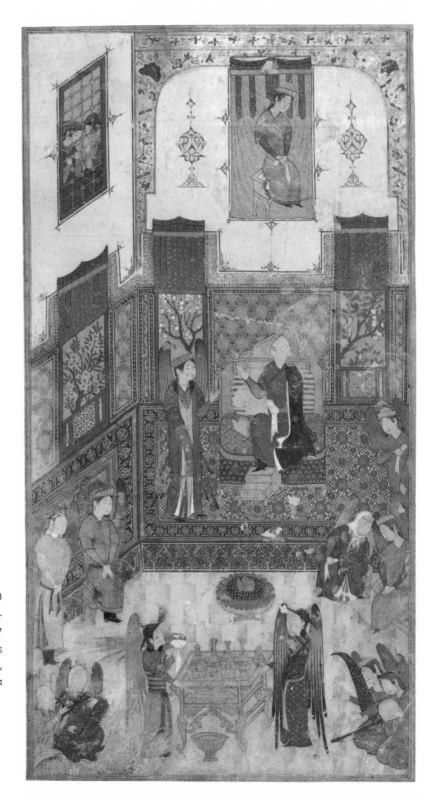

Plate 13
Academy of Baysunghur
Humay in the Fairy Palace, 1427
8½ x 4½ inches
Osterreichische Nationalbibliothek,
Vienna

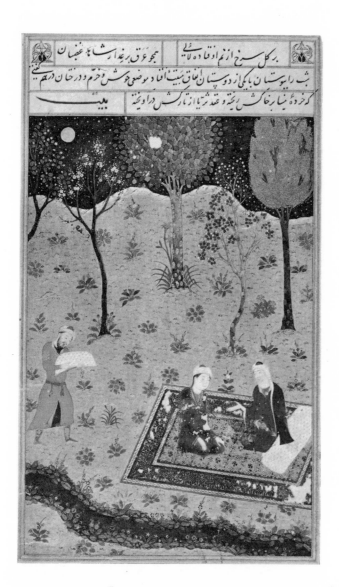

Plate 14

Academy of Baysunghur
*The Poet Sa 'di and a Friend in
a Garden at Night,* 1426
opaque colors and gold
5⅝ x 3-15/16 inches
The Chester Beatty Library,
Dublin

Plate 15

Academy of Baysunghur
*The Crow Addressing
the Wise Mouse,* 1430
watercolor on paper
7⅞ x 6-11/16 inches
Topkapi Sarayi Library, Istanbul

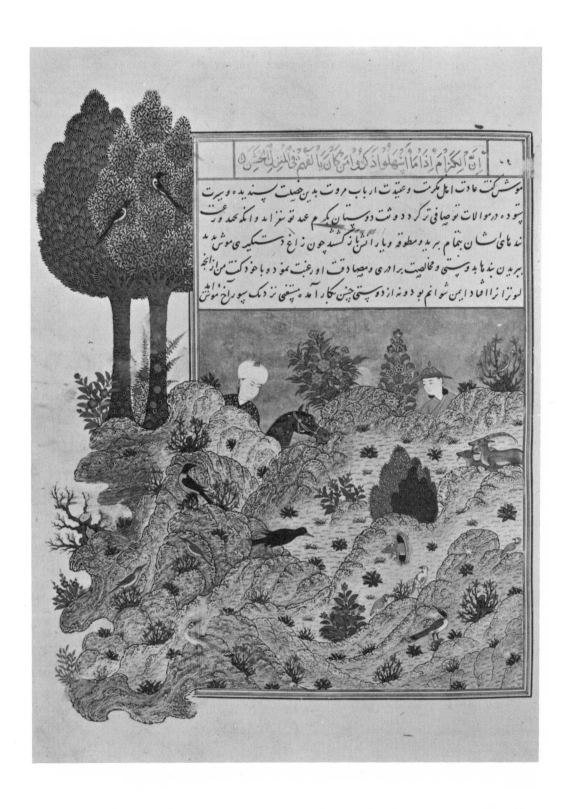

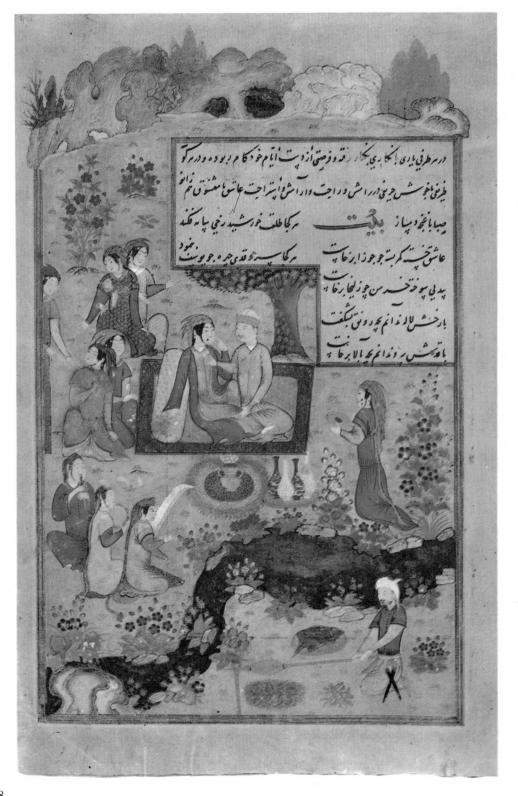

Plate 16

Academy of Baysunghur
*Prince Baysunghur Dallying with
His Ladies*, 1426
opaque colors and gold
8⅛ x 5½ inches
Florence, Berenson Collection,
Reproduced by Permission of the
President and Fellows of
Harvard College

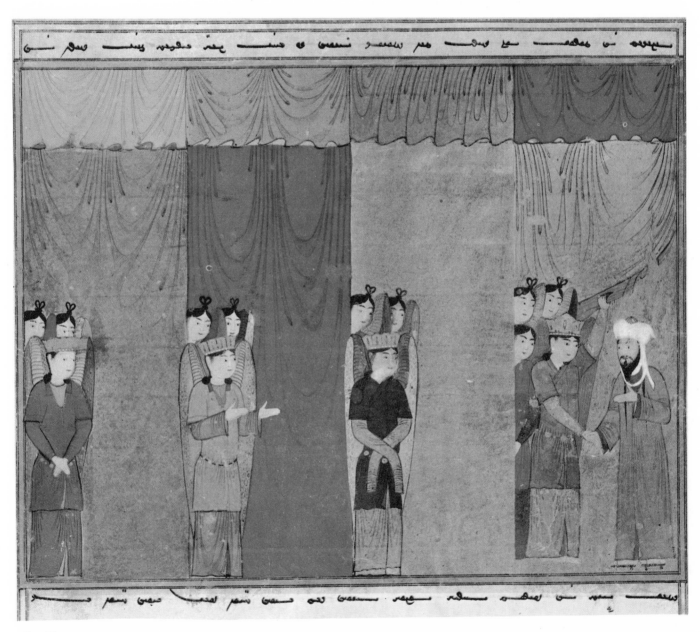

Plate 17

ANONYMOUS, Herat School · *Muhammad Received by the Four Archangels*, 1436 · opaque colors and gold, 13½ x 9⅞ inches · Bibliothèque Nationale, Paris

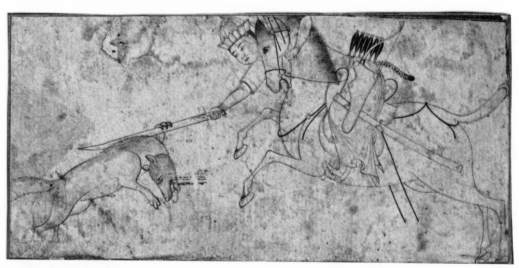

Plate 18

Academy of Baysunghur • *Prince Baysunghur Hunting*, ca. 1430 • ink and brush on paper, 2⅝ x 5-7/16 inches • Courtesy of the Fogg Art Museum, Harvard University

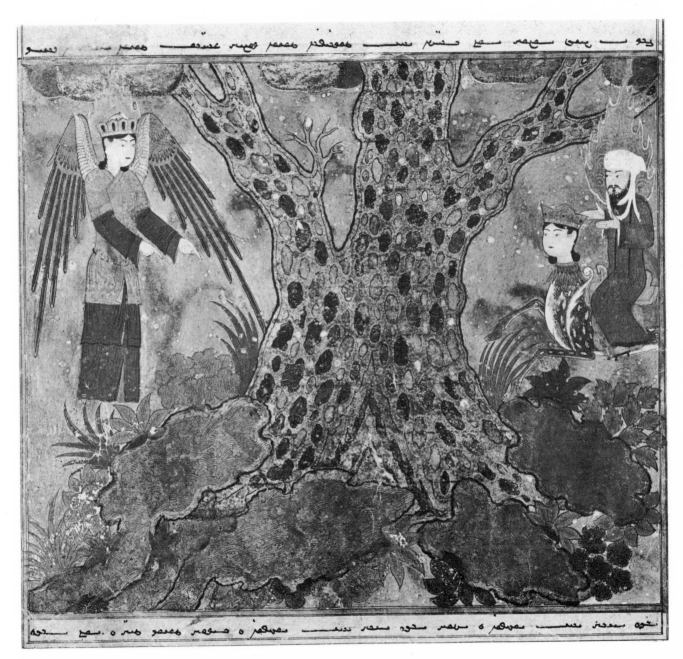

Plate 19

ANONYMOUS, Herat School • *Muhammad Sees the Tree of Jewels in Heaven*, 1436 • Bibliothèque Nationale, Paris

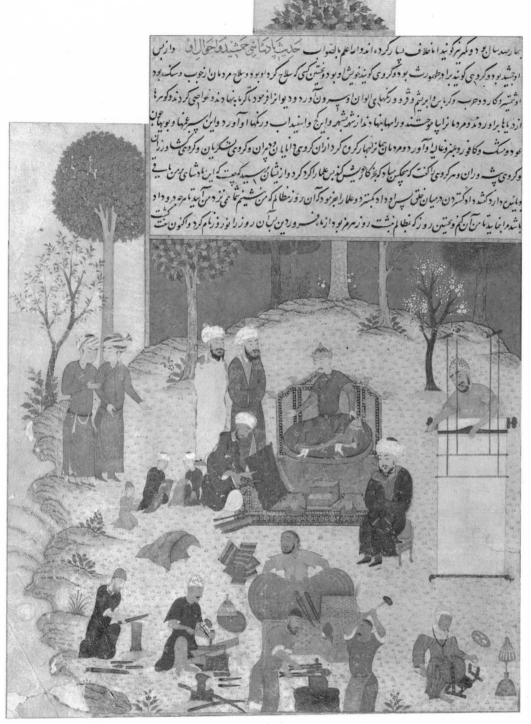

Plate 20
ANONYMOUS, Herat School
Jamshid Teaching the
Crafts, 1469
opaque colors and gold
11¼ x 7⅞ inches
Dublin
The Chester Beatty Library,

Plate 21
ANONYMOUS, Herat School
Prince and Ladies under a Paeony
Branch, ca. 1450
12-7/16 x 9⅛ inches
Museum of Fine Arts, Boston

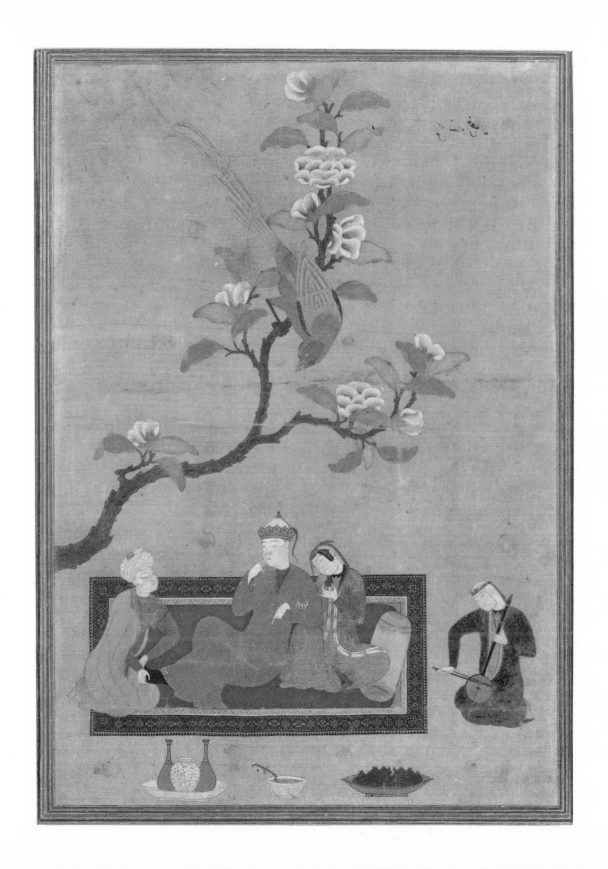

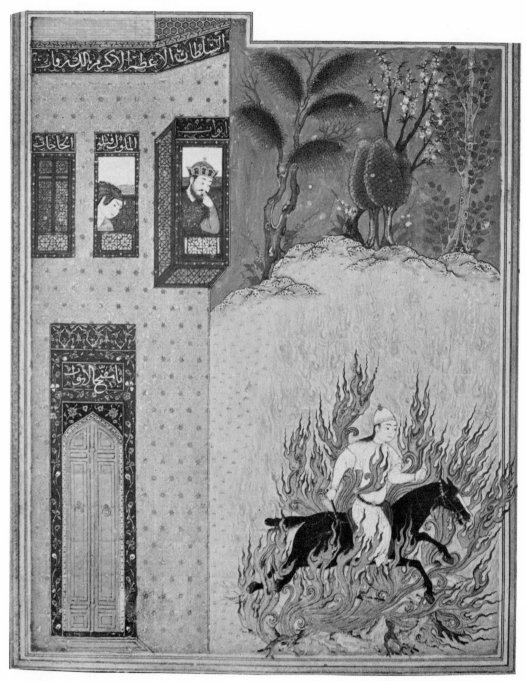

Plate 22

ANONYMOUS, Herat School • *The Fire-Ordeal of Siyawush,* ca. 1440 • colors on paper,
6½ x 5½ inches • Royal Asiatic Society Library, London

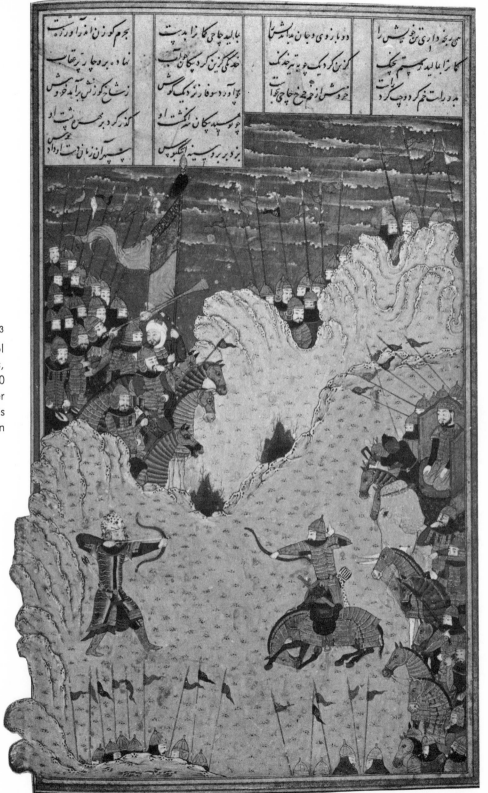

Plate 23

ANONYMOUS, Herat School
Combat of Rustam and Ashkabus,
ca. 1440
colors on paper
7¾ x 5¼ inches
Royal Asiatic Society Library, London

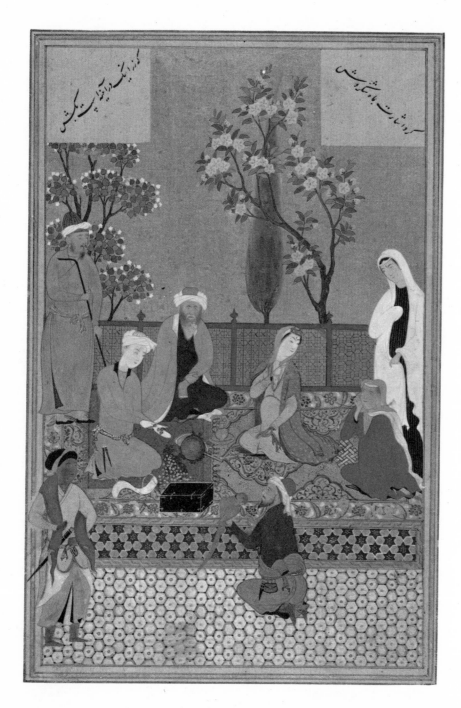

Plate 24

Probably by BIHZAD
The Lady and the Banker, 1485
opaque colors and gold
6¾ x 4½ inches
The Chester Beatty Library,
Dublin

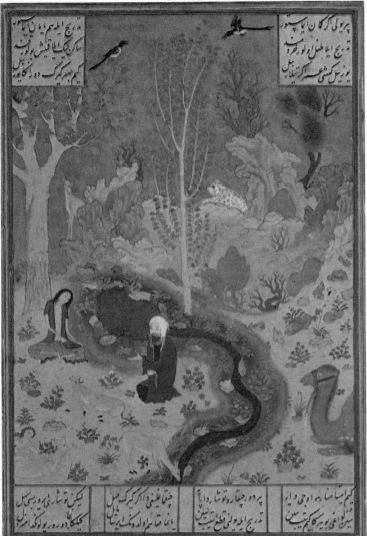

Plate 25

School of Bihzad • *Majnun Visited by Salim*,
1485 • watercolor with gold and colors on
paper, 5¾ x 4-7/16 inches • The John
Rylands Library, Manchester, England

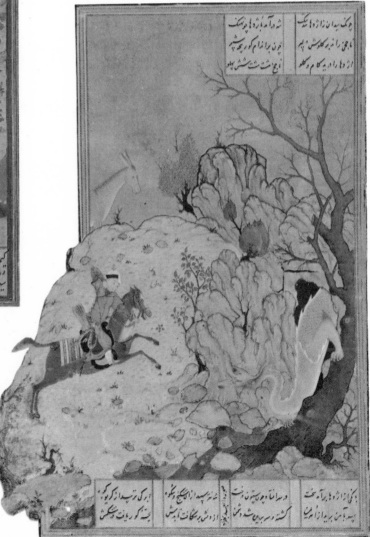

Plate 26

BIHZAD • *Bahram Gur and the Dragon*,
ca. 1490 • 7½ x 4¾ inches • British Museum,
London

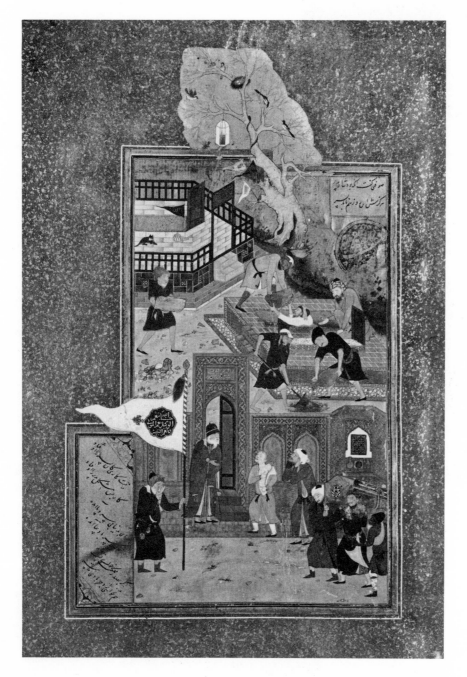

Plate 27

Probably by BIHZAD
Funeral Procession and Builders at Work, ca. 1485
9¾ x 5½ inches
The Metropolitan Museum of Art,
New York, Purchase, 1963,
Fletcher Fund

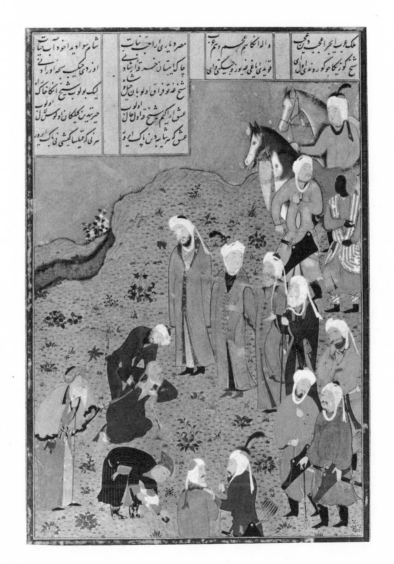

Plate 28

Probably by QASIM 'ALI
Shaykh 'Iraqi Overcome at
Parting, 1485
opaque colors and gold
5½ x 4⅛ inches
Bodleian Library, Oxford

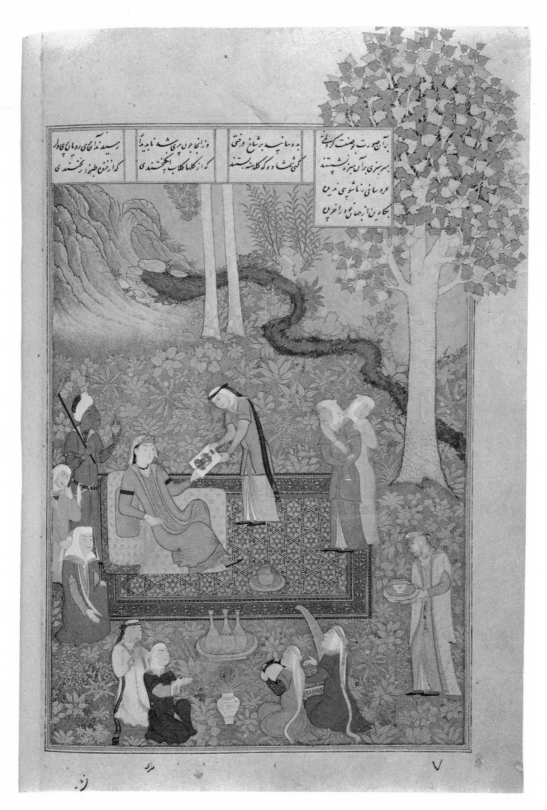

Plate 29

MIRAK
*Khusraw's Portrait Shown
to Shirin*, 1495
9½ x 6½ inches
British Museum, London

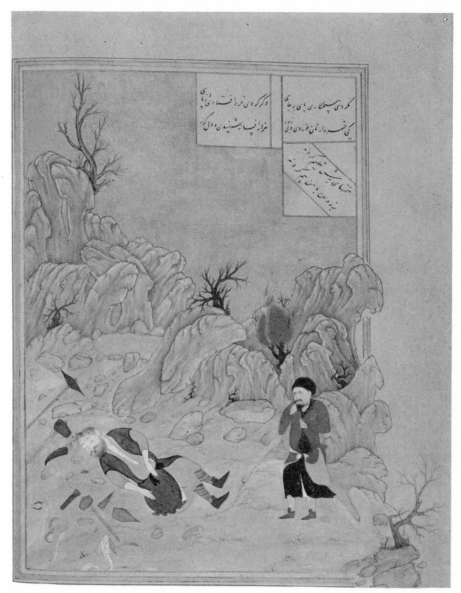

Plate 30

School of Bihzad • *The Death of Farhad*, 1495 • 9½ x 6½ inches • British Museum, London

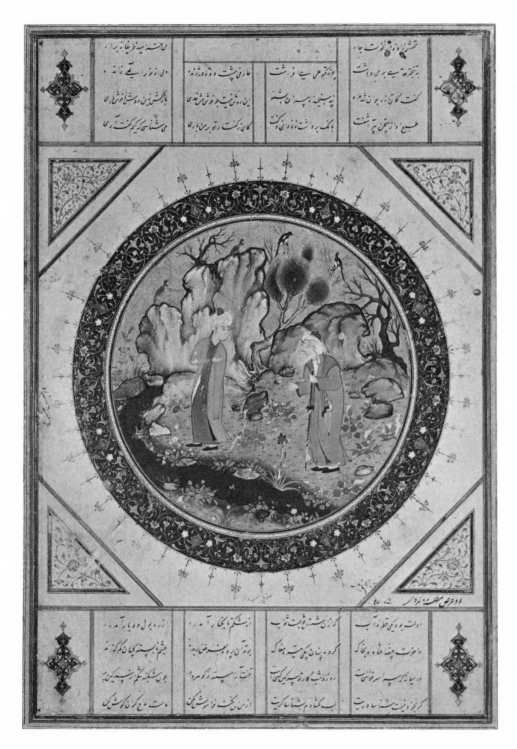

Plate 31

BIHZAD
Youth and Old Age, 1524
color, gold, and silver
3¼ inches diameter
Courtesy of the Smithsonian
Institution, Freer Gallery of Art,
Washington, D. C.

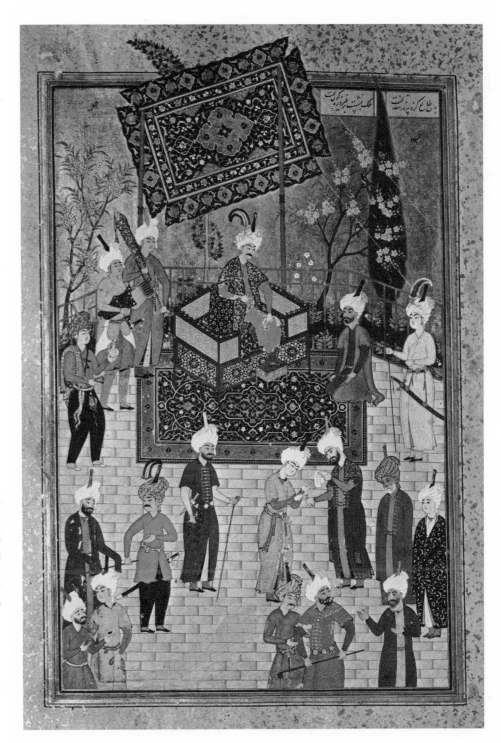

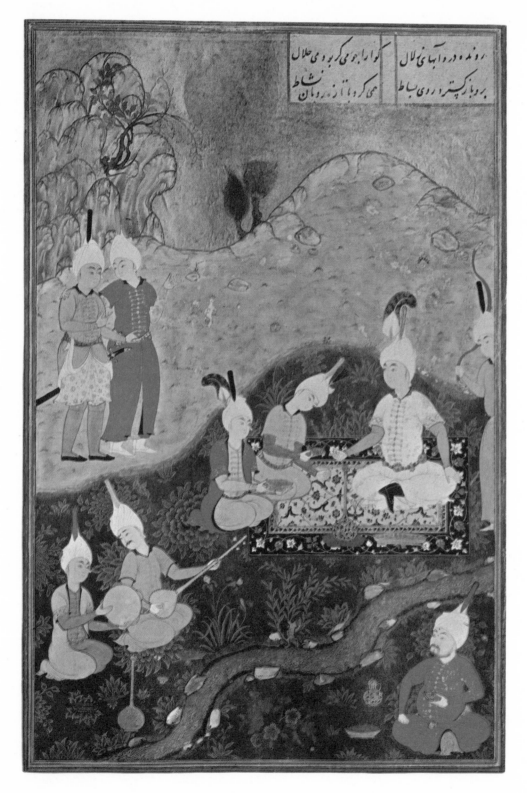

Plate 33

Perhaps by MIR MUSAWWIR
*Iskandar Entertained by the
Khaqan*, 1525
12¾ x 8¾ inches
The Metropolitan Museum of
Art, New York, Gift of
Alexander Smith Cochran, 1913

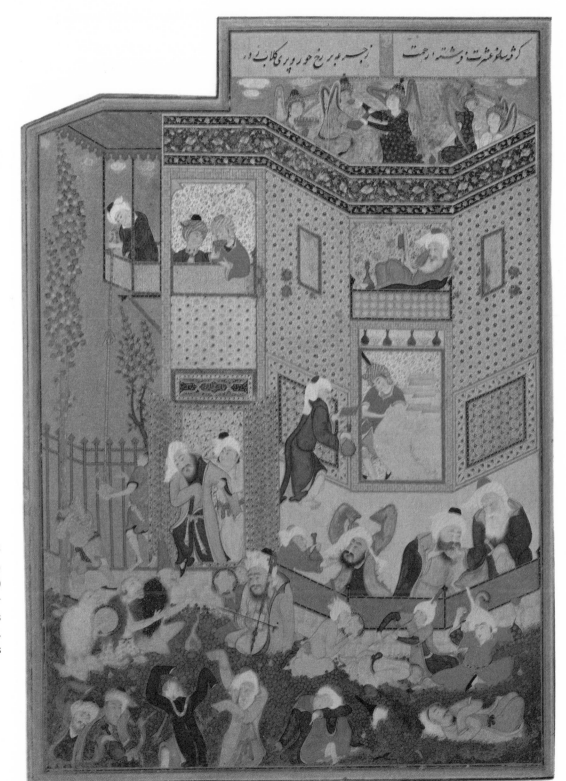

Plate 34
SULTAN MUHAMMAD
The Triumph of Bacchus, ca. 1530
gouache on paper
8½ x 6 inches
Private Collection,
Cambridge, Massachusetts

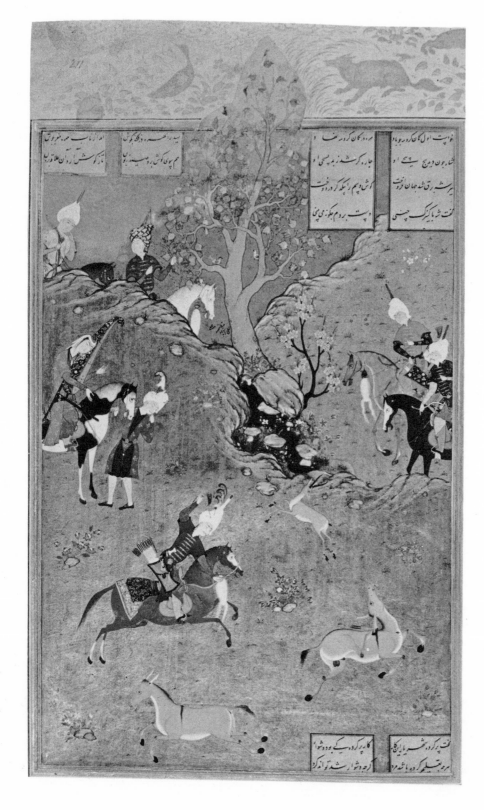

Plate 35

MUZAFFAR 'ALI
Bahram Gur Hunting the Wild Ass,
ca. 1540
14½ x 10 inches
British Museum, London

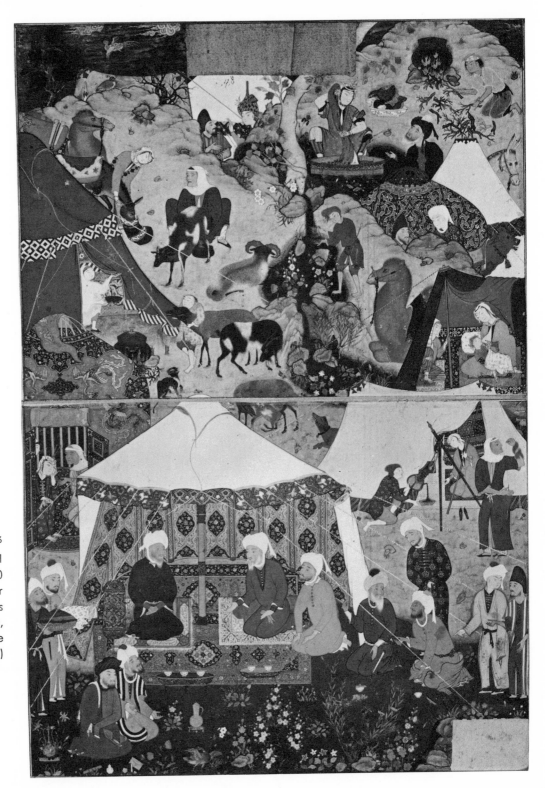

Plate 36
MIR SAYYID 'ALI
Camp Scene, ca. 1540
gouache on paper
10⅞ x 7-9/16 inches
Courtesy of the Fogg Art Museum,
Harvard University (Formerly of the
Louis J. Cartier Collection)

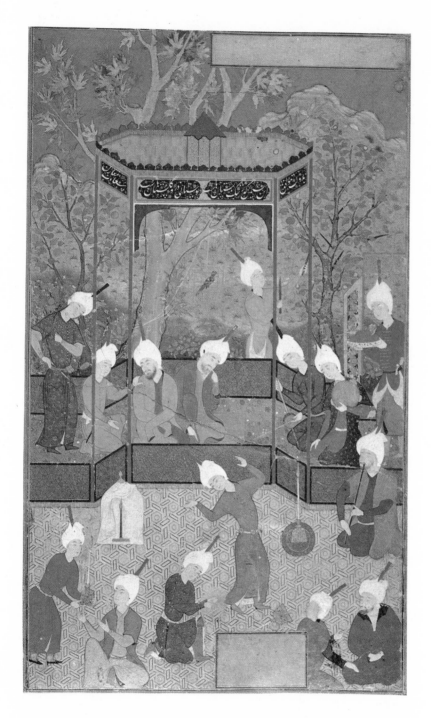

Plate 37

Perhaps by MIRZA 'ALI
Night Entertainment on a Terrace,
ca. 1540
opaque colors and gold
6 x 11⅜ inches
The Chester Beatty Library, Dublin

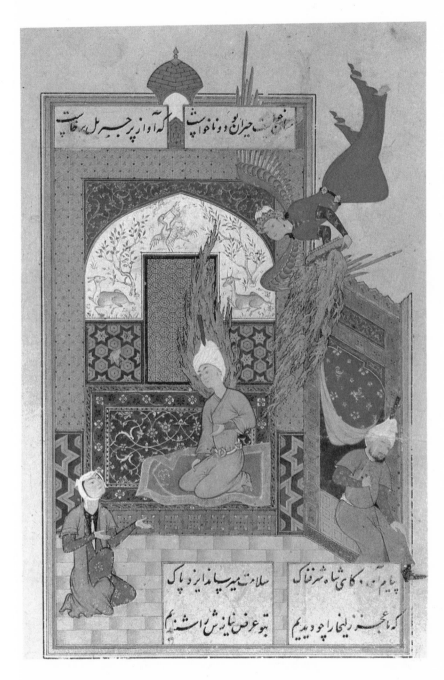

Plate 38

Probably by MIRZA 'ALI • *An Angel Descending upon Yusuf*, 1540 •
opaque colors and gold, 6⅝ x 4-3/16 inches • The Chester Beatty Library, Dublin

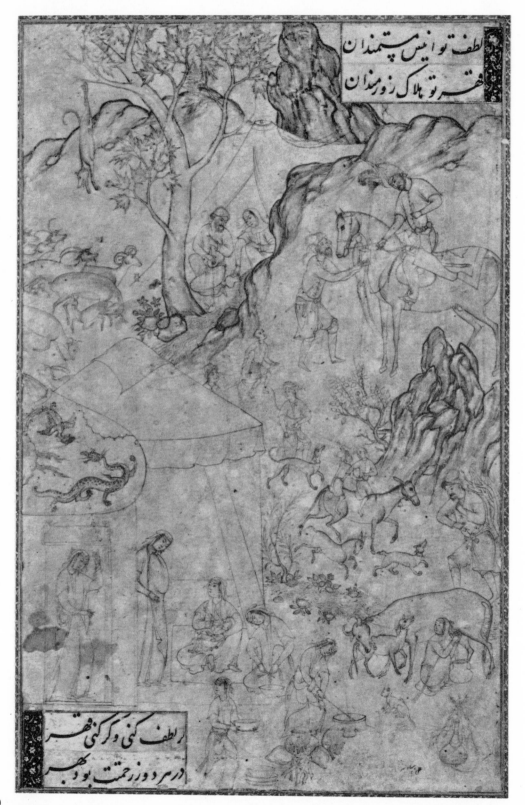

Plate 39

ANONYMOUS, Qazwin Style
*Bahram Gur and the Shepherd who
Hanged His Dog*, ca. 1540–50
17¾ × 11⅝ inches
Museum of Fine Arts, Boston

Plate 40

MUHAMMADI
Pastoral Scene, 1578
line drawing with touches of brown
9½ x 5⅞ inches
Musée Guimet, Paris

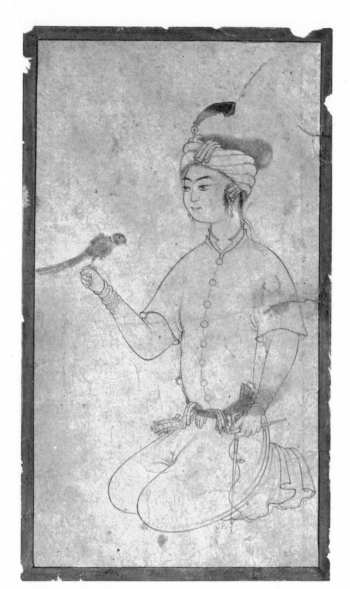

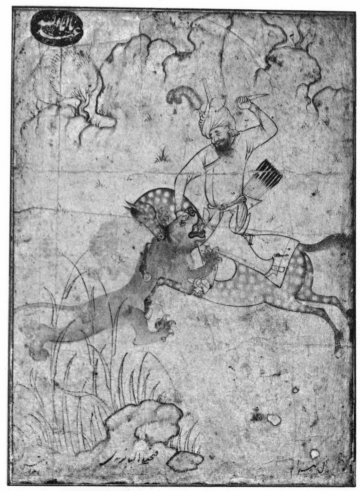

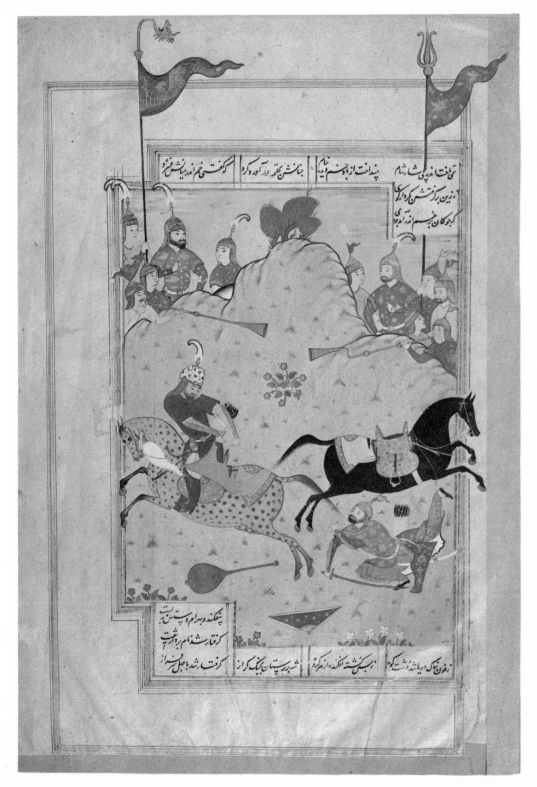

Plate 43
SIYAWUSH
Rustam Lassoing Kamus,
ca. 1576
opaque color and gold
17-5/16 x 12-3/16 inches
Collection of Dr. and Mrs.
Schott, Gerrards Cross,
England (From the Collection
of the Late Mr. Paul Loewi)

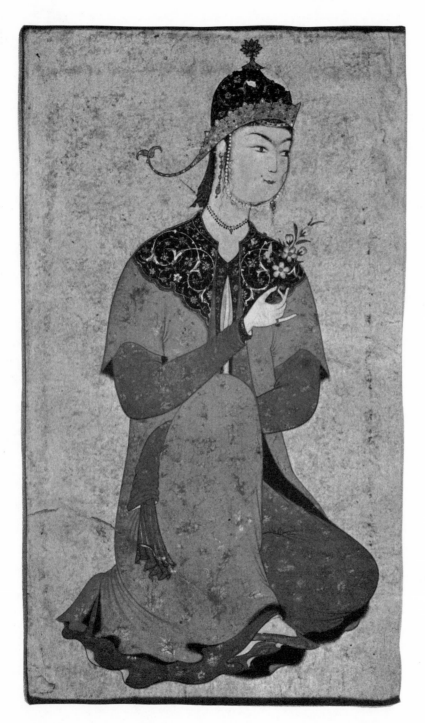

Plate 44

ANONYMOUS, Qazwin Style
Seated Princess, ca. 1550
gouache on paper
7⅛ x 4-3/16 inches
Courtesy of the Fogg Art Museum,
Harvard University (Formerly of the
Louis J. Cartier Collection)

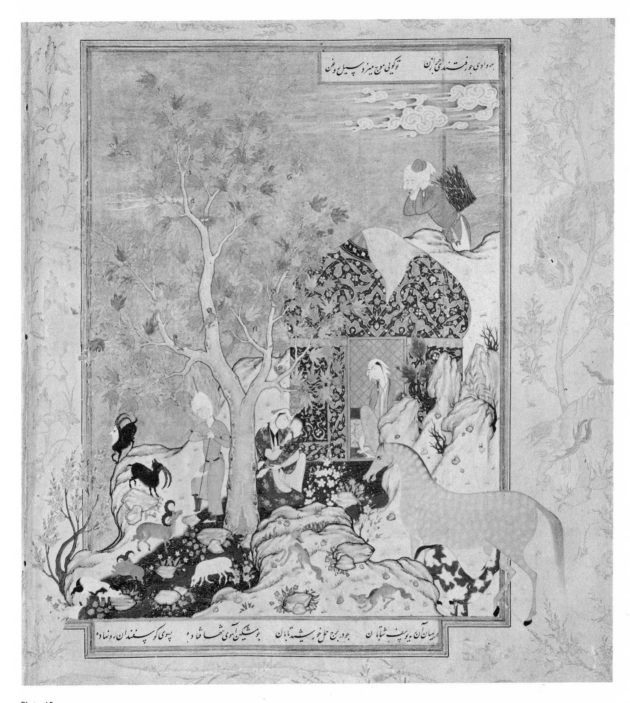

Plate 45

ANONYMOUS, Qazwin Style • *Yusuf Tending the Flock,* ca. 1560 • ink, 8⅜ x 6-11/32 inches • Courtesy of the Smithsonian Instituton, Freer Gallery of Art, Washngton, D. C.

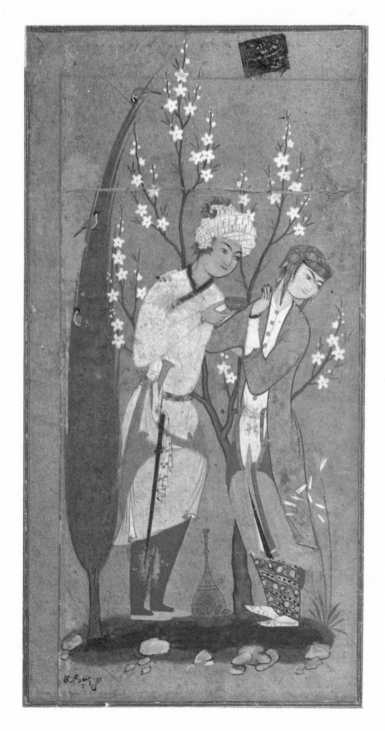

Plate 46

MUHAMMADI
Lovers, ca. 1575
7-1/16 x 3-9/16 inches
Museum of Fine Arts, Boston

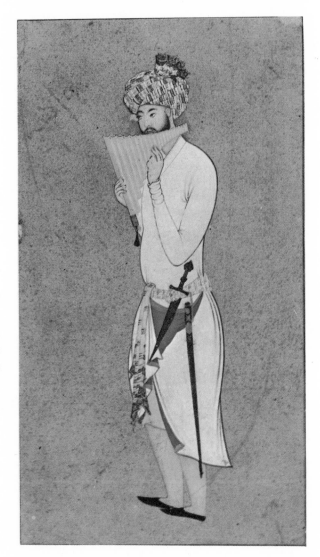

Plate 47

MUHAMMAD MU 'MIN
Man Playing the Panpipes,
ca. 1580–90
5-5/16 x 2-15/16 inches
Museum of Fine Arts. Boston

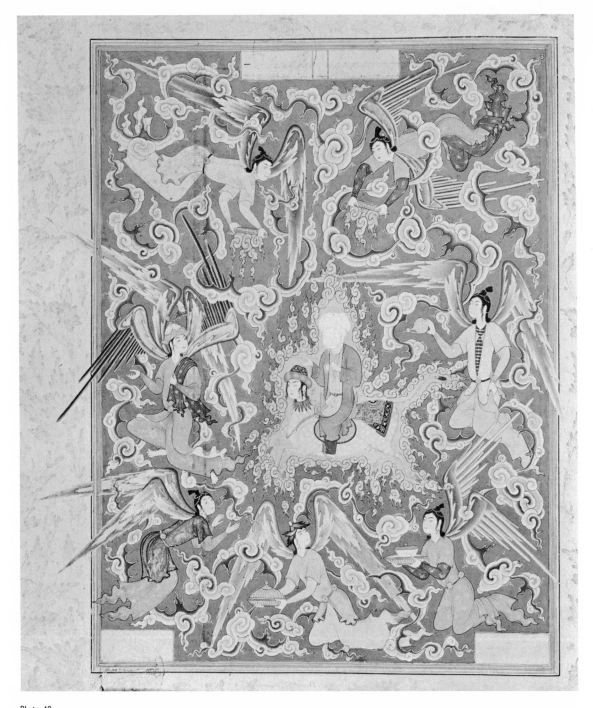

Plate 48

ANONYMOUS, Qazwin Style • *The Heavenly Ascent of the Prophet Muhammad*, ca. 1560 • ink, 9½ x 7¼ inches •
Courtesy of the Smithsonian Institution, Freer Gallery of Art, Washington, D. C.

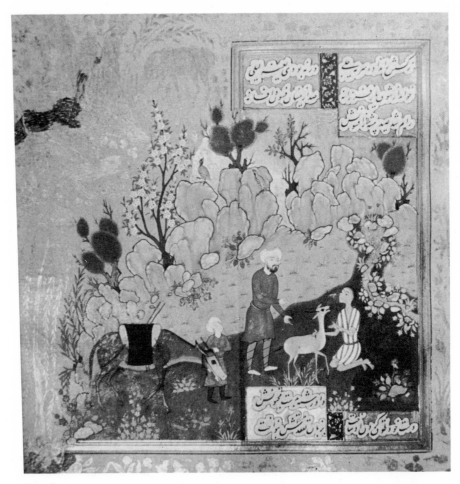

Plate 49

ANONYMOUS, Qazwin Style • *Majnun Ransoming the Antelope*, 1569 • opaque
colors and gold, 9⅝ x 6⅛ inches • Gulistan Palace Library, Tehran

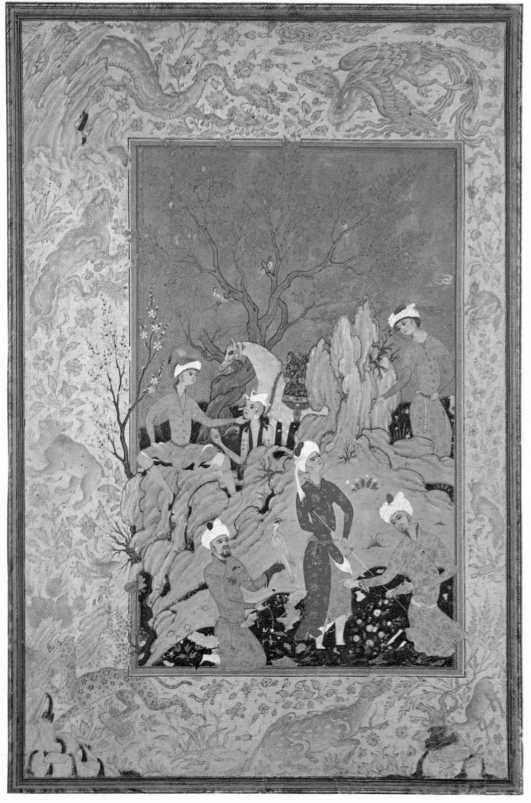

Plate 50

ANONYMOUS, Qazwin Style
A Hawking Party in the Mountains,
ca. 1580
18⅝ x 12¾ inches
The Metropolitan Museum of Art,
New York,
Purchase, 1912, Rogers Fund

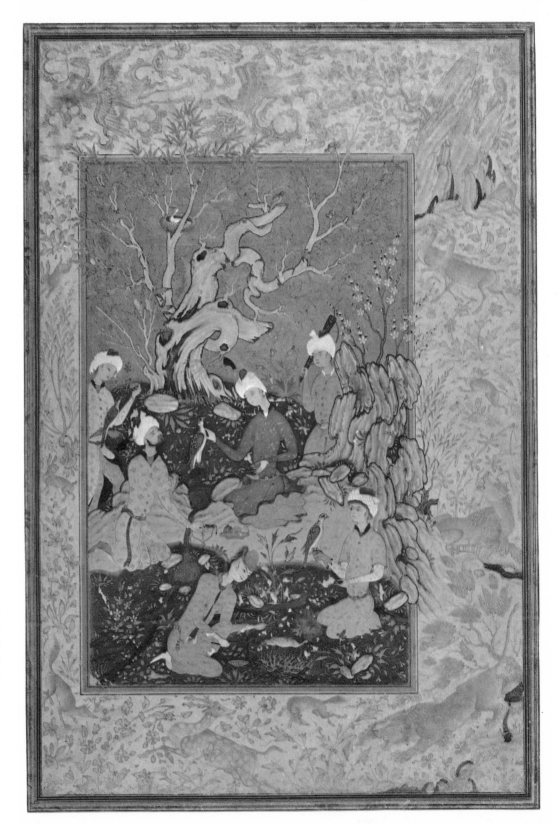

Plate 51

ANONYMOUS, Qazwin Style
*A Hawking Party in the
Mountains*, ca. 1580
18⅝ x 12¾ inches
Museum of Fine Arts, Boston

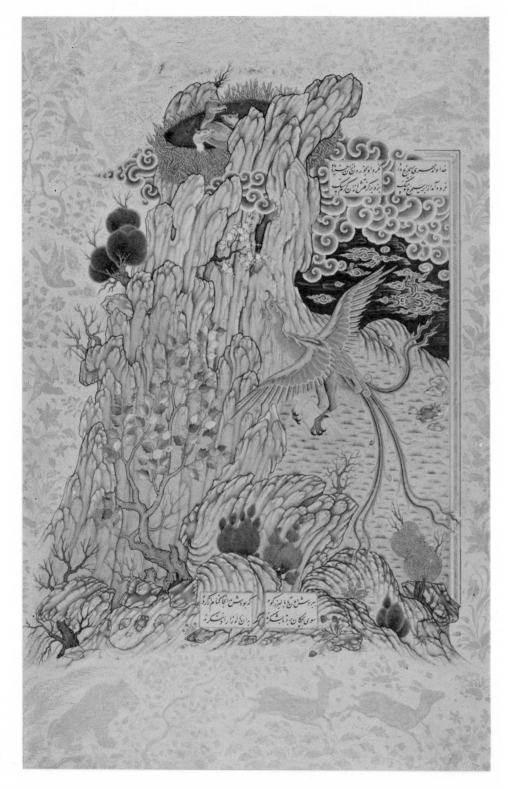

Plate 52
ANONYMOUS, Isfahan Style
*The Simurgh Carrying Zal to
Her Nest,* ca. 1590
opaque colors and gold
15½ x 10¼ inches
The Chester Beatty Library, Dublin

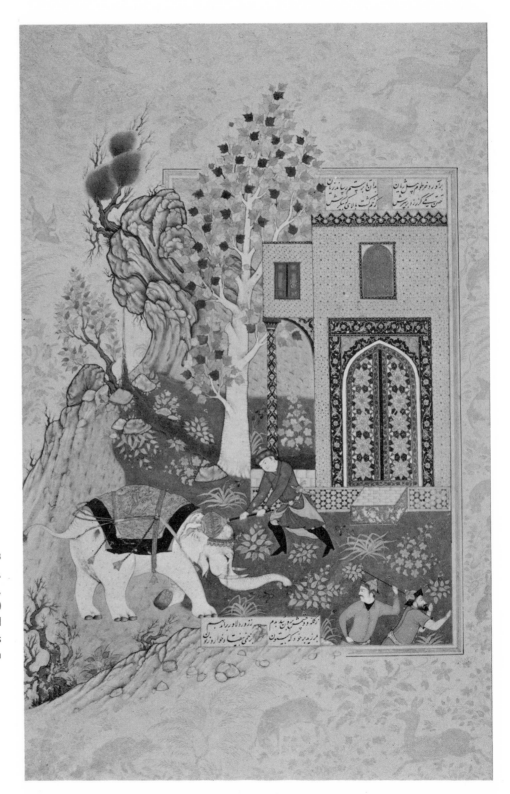

Plate 53
AQA RIZA
Rustam and the Mad Elephant,
ca. 1590
opaque colors and gold
15½ x 10¼ inches
The Chester Beatty Library, Dublin

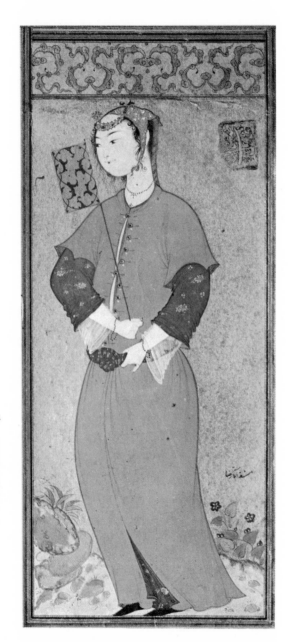

Plate 54

AQA RIZA
Girl with a Fan, ca. 1590
color and gold ground on paper
6⅜ x 3⅞ inches
Courtesy of the Smithsonian
Institution, Freer Gallery of Art,
Washington, D.C.

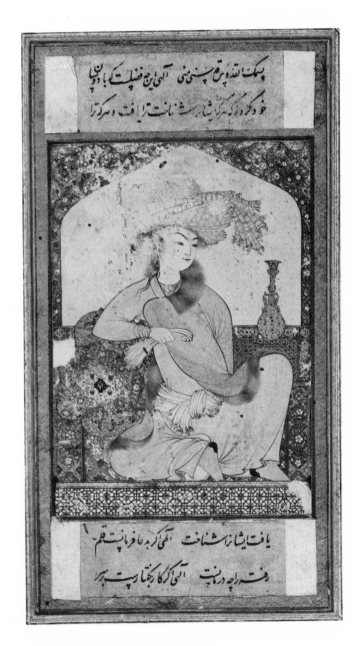

Plate 55

ANONYMOUS, Isfahan Style
Seated Youth, ca. 1600
ink and wash
6 x 4½ inches
The Pierpont Morgan Library,
New York

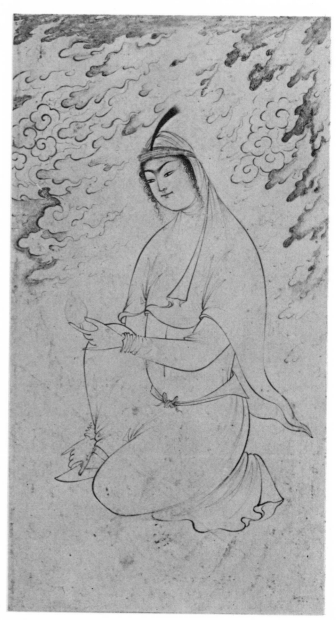

Plate 56
MUHAMMAD YUSUF • *Young Man Seated
under a Tree*, 1637 • ink and wash, 6 x 3¾
inches • Private Collection, London

Plate 57
HABIBALLAH of Mashhad • *Seated Lady*,
ca. 1600 • ink and wash, 6¼ x 3½ inches •
Private Collection, London

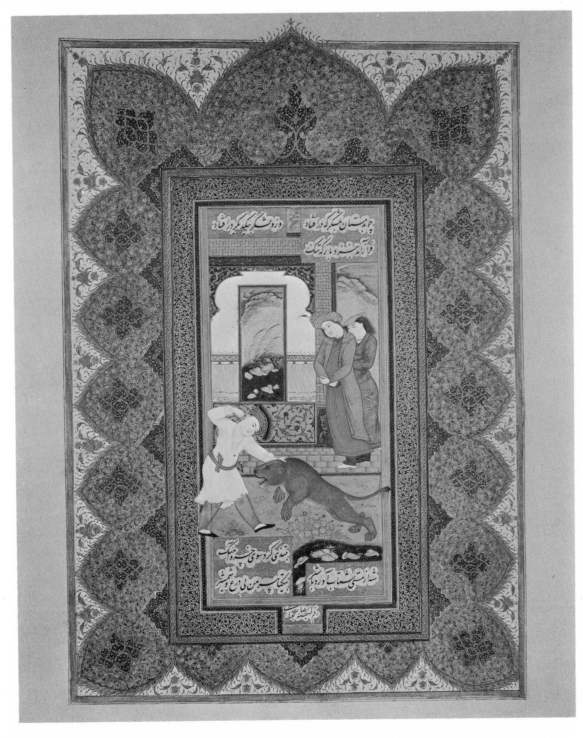

Plate 58

RIZA-I 'ABBASI · *Khusraw and the Lion*, 1632 · gouache on paper, 12¼ x 8⅞ inches · Victoria and Albert Museum

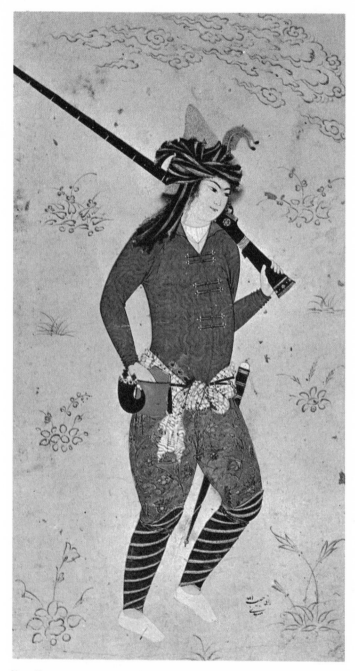

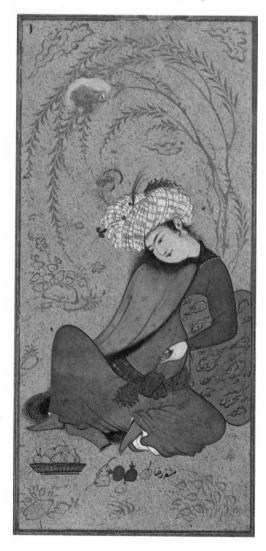

Plate 60

AQA RIZA • *Seated Youth, ca. 1600* •
5⅜ x 2½ inches • The Metropolitan Museum
of Art, New York, Purchase, 1955, Rogers Fund

Plate 59

HABIBALLAH of Mashhad • *Young Huntsman Carrying His Gun,*
ca. 1600 • opaque colors and gold, 7⅛ x 3¾ inches •
Staatliche Museen (Islamisches Museum), Berlin

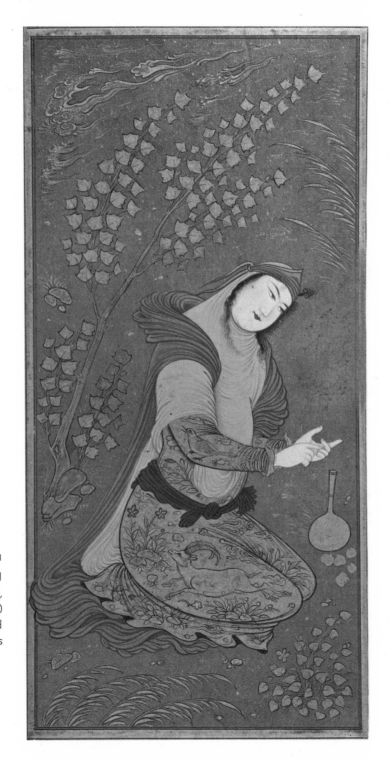

Plate 61
RIZA-I 'ABBASI
Lady Counting on Her Fingers,
ca. 1630
opaque colors and gold
Bibliothèque Nationale, Paris

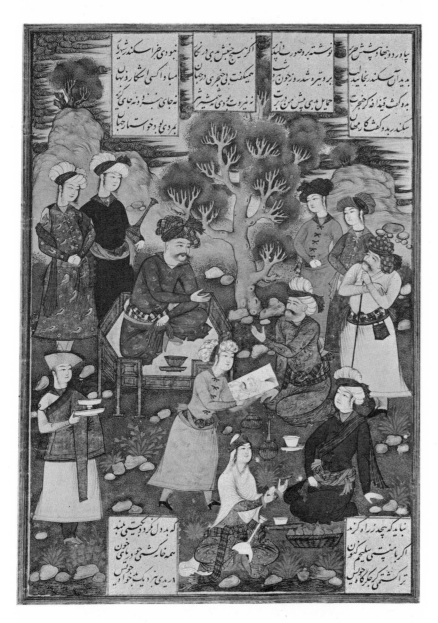

Plate 62

Probably by MUHAMMAD QASIM
*Iskandar Preparing His Portrait for
Queen Qaydafa*, 1648
opaque colors and gold
17¼ x 11 inches
Windsor Castle, Royal Library

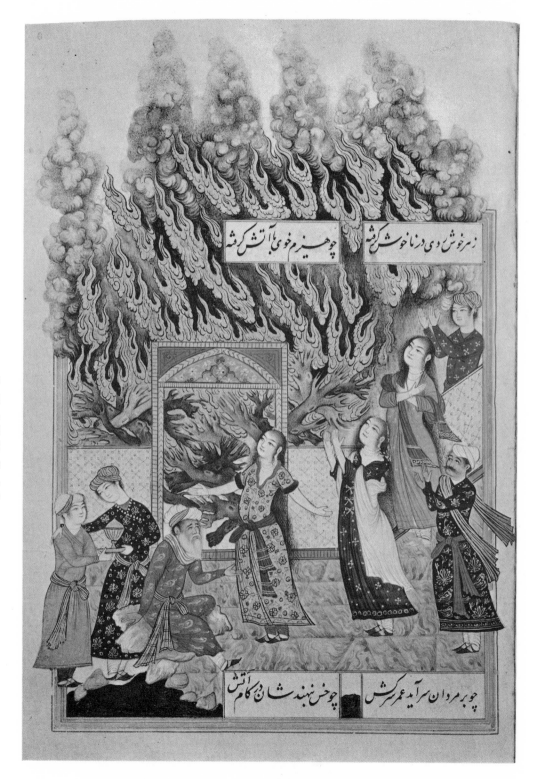

Plate 63
MUHAMMAD QASIM
The Worship of Fire in India,
ca. 1650
opaque colors and gold
5⅜ x 7¾ inches
The Chester Beatty Library,
Dublin

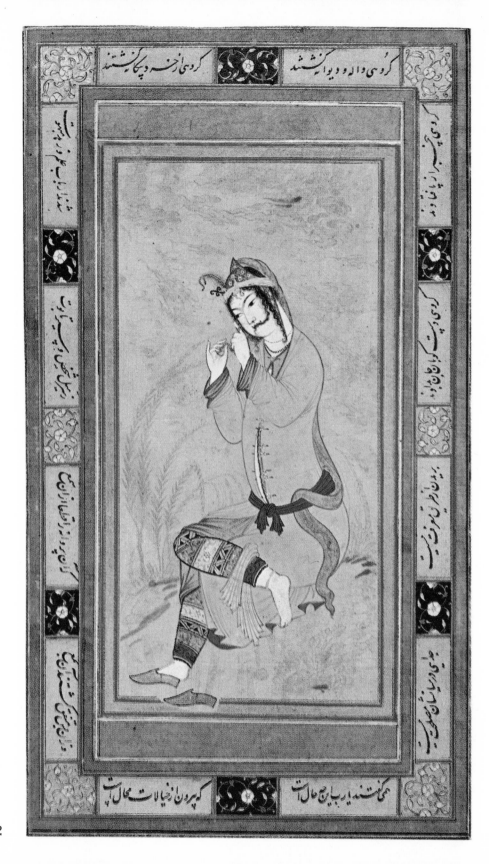

Plate 64

ANONYMOUS, Isfahan Style
Girl Arranging Her Hair,
ca. 1610–20
gouache on paper
6 x 2⅞ inches
Victoria and Albert Museum,
London

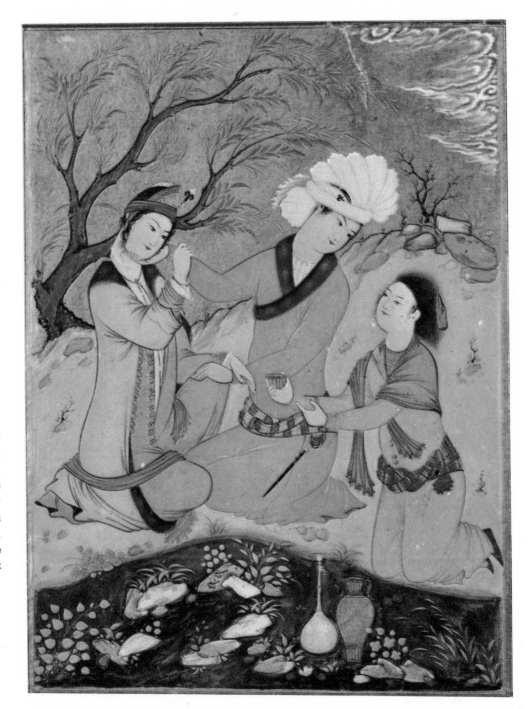

Plate 65

RIZA-I 'ABBASI
*Lovers Served with Wine by an
Attendant,* ca. 1620
gold and color on paper
7½ x 5½ inches
Seattle Art Museum, Washington,
Gift of the late
Mrs. Donald E. Frederick

Plate 66
MUHAMMAD 'ALI
Girl in a Furred Bonnet,
ca. 1650—60
grisaille heightened with gold
and colors
2¾ x 1-11/16 inches
Musée Guimet, Paris

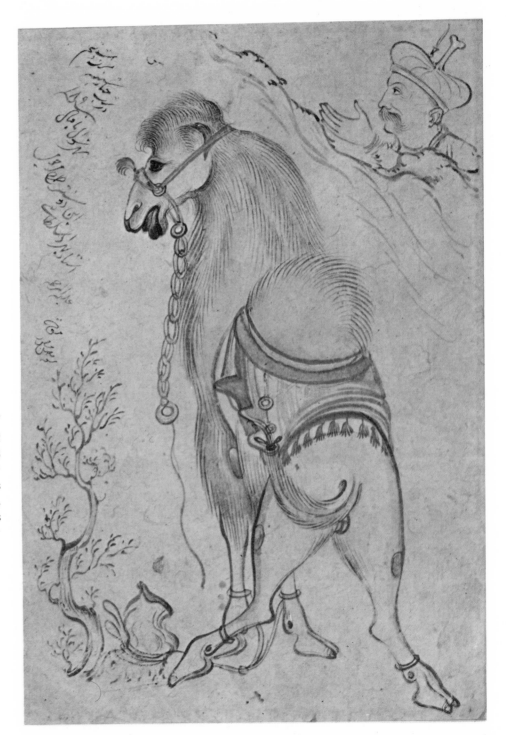

Plate 67

MU'IN MUSAWWIR
A Camel, 1678
brush, ink, and watercolor on paper
7¼ x 5-1/16 inches
Private Collection, Cambridge,
Massachusetts

Plate 68

AFZAL AL-HUSAYNI · *Lovers*, 1647 · gouache on paper, 4½ x 7⅛ inches · Victoria and Albert Museum, London

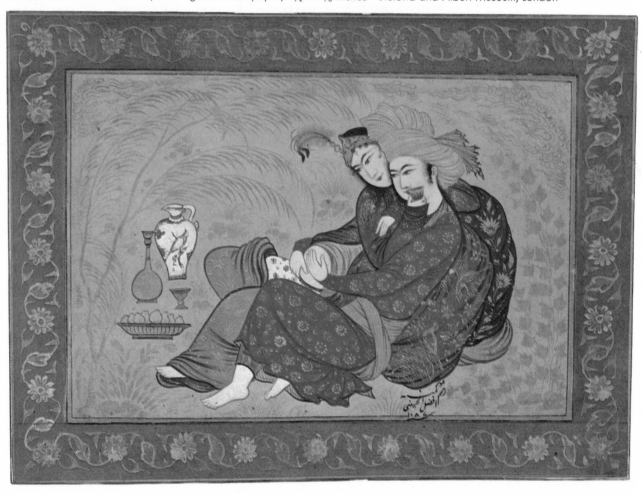

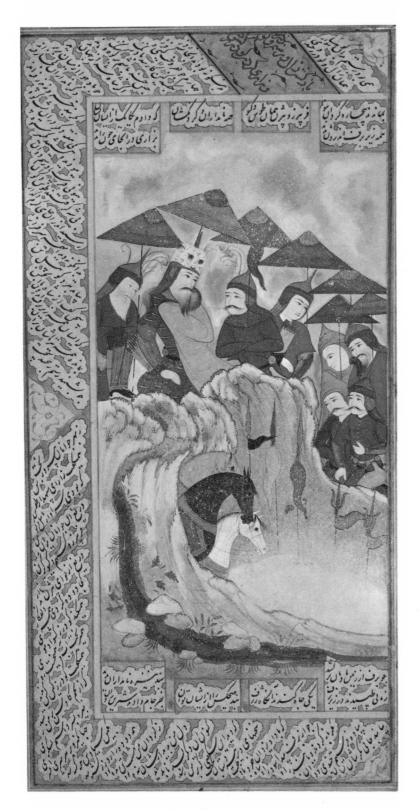

Plate 69
MU'IN MUSAWWIR
The Paladins in the Snow, 1649
gouache on paper
9-3/16 x 4-9/16 inches
Courtesy of the Fogg Art Museum,
Harvard University

Plate 70

ANONYMOUS, Timurid Style of Shiraz • *Rustam Slaying the Demon Arzhang, ca. 1435* • opaque colors and gold, 5 x 5¾ inches • Bodleian Library, Oxford

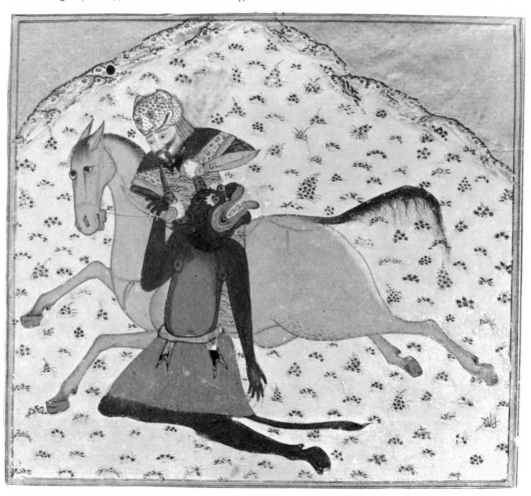

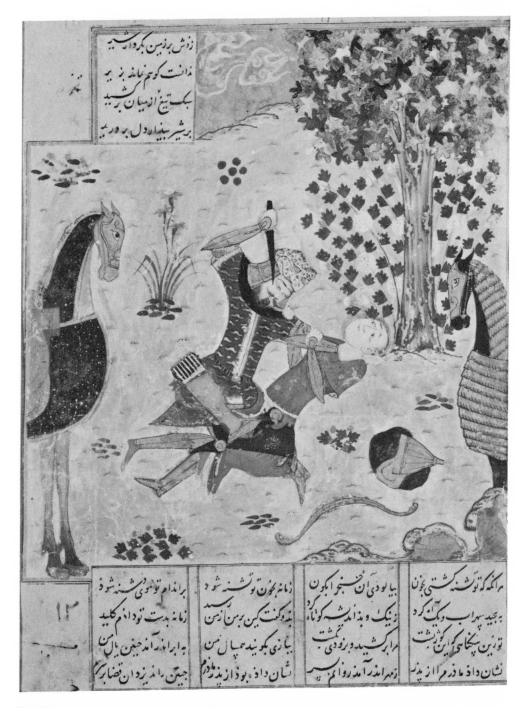

Plate 71

ANONYMOUS, Timurid Style of Shiraz • *Rustam and Suhrab*, ca. 1435–40 • 7 1/8 x 5-7/16 inches •
British Museum, London

Plate 72

ANONYMOUS, Timurid Style of Shiraz · *Princess Sarai Mulk Khanum Meeting Officers of the Army in Persia,*
1436 · color and gold on paper, 9½ x 7¾ inches · Seattle Art Museum, Washington, Eugene Fuller
Memorial Collection

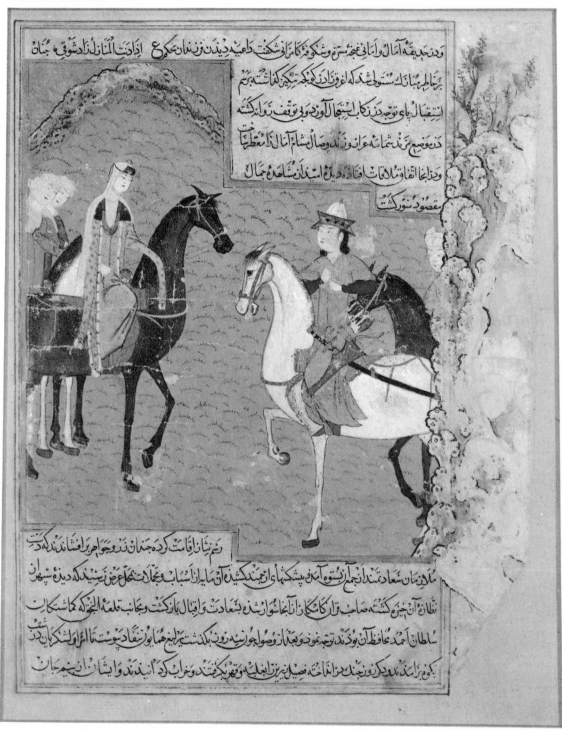

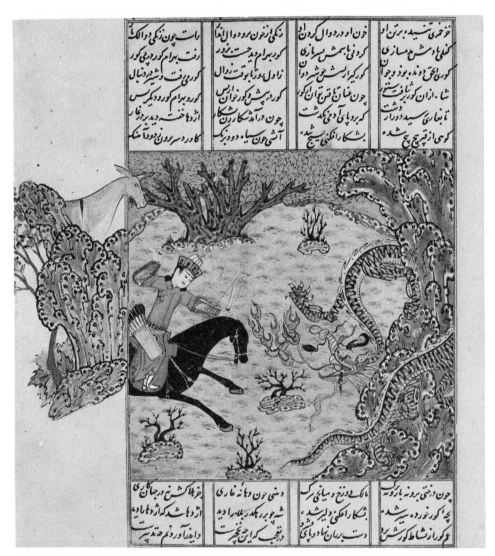

Plate 73

ANONYMOUS, Timurid Style of Shiraz • *Bahram Gur and the Dragon*, 1445 • watercolor with gold and colors on paper, 4⅛ x 5¾ inches • The John Rylands Library, Manchester, England

Plate 74

ANONYMOUS, Timurid
Style of Shiraz
The Court of Khan Kuyuk, 1438
7½ x 4⅝ inches
British Museum, London

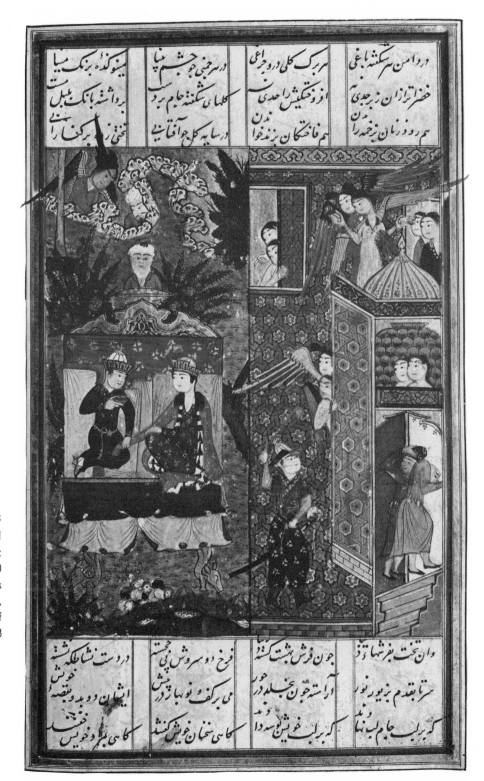

Plate 75
ANONYMOUS, Timurid
Style of Shiraz
Layla and Majnun in Paradise, 1450
10 x 6¼ inches
The Metropolitan Museum of Art,
New York, Gift of
Alexander Smith Cochran, 1913

Plate 76

ANONYMOUS, Timurid Provincial Style • *Combat of Bizhan and Farud,* ca. 1440
7-3/16 x 6-13/16 inches • The Metropolitan Museum of Art, New York, Bequest of
William Milne Grinell, 1920

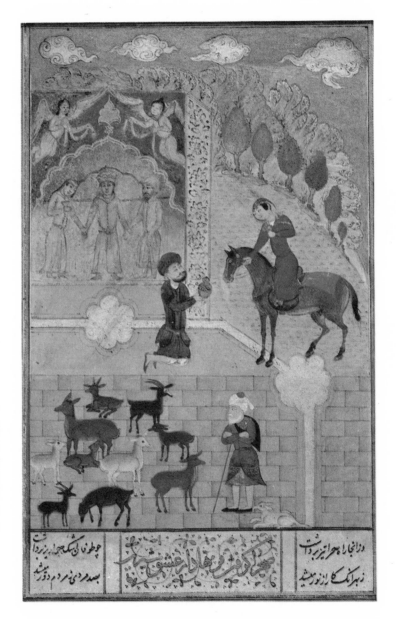

Plate 77
ANONYMOUS, Timurid
Provincial Style
*Shirin Visiting Farhad at
Mount Behistun*, 1481
opaque colors and gold
4⅜ x 6-1/16 inches
The Chester Beatty Library, Dublin

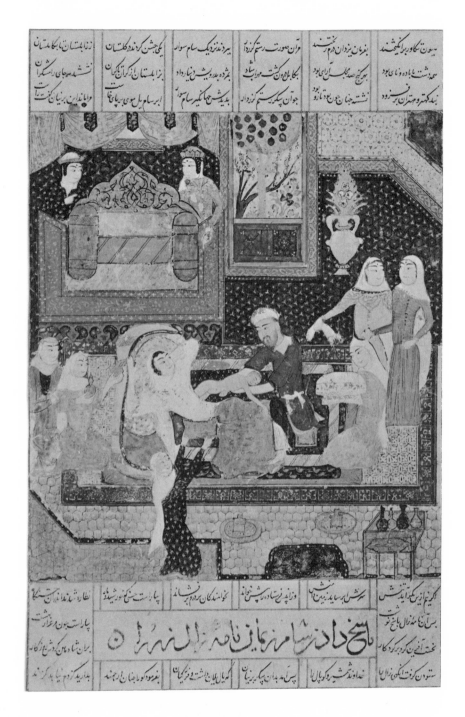

Plate 78
ANONYMOUS, Timurid
Provincial Style
The Birth of Rustam, ca. 1450
opaque colors and gold
5¼ x 4¾ inches
Private Collection, London

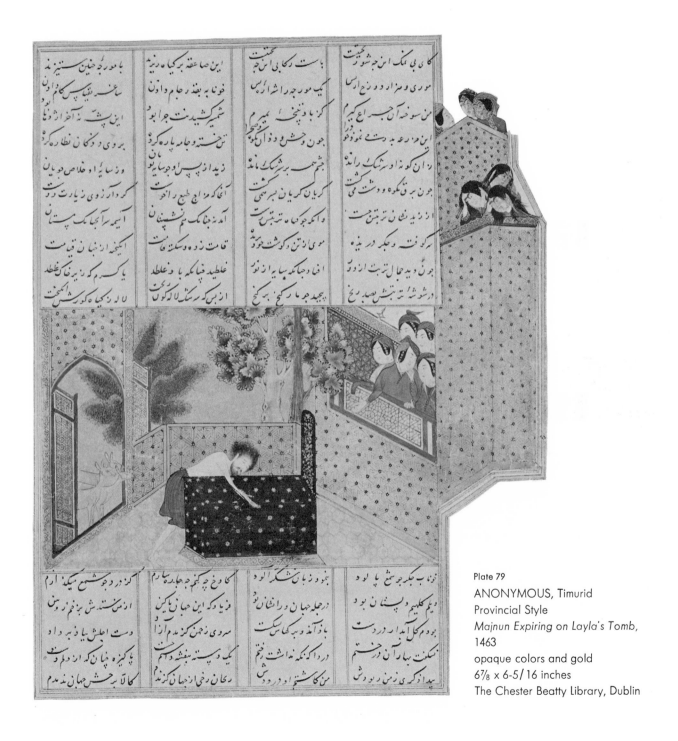

Plate 79
ANONYMOUS, Timurid
Provincial Style
Majnun Expiring on Layla's Tomb,
1463
opaque colors and gold
6⁷⁄₈ x 6-5/16 inches
The Chester Beatty Library, Dublin

Plate 80

ANONYMOUS, Turkman Style
Prince and Attendants in a Garden,
1478
opaque colors and gold
4⅜ x 4½ inches
The Chester Beatty Library, Dublin

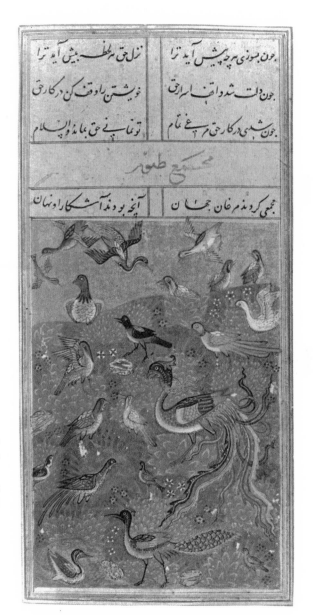

Plate 81
ANONYMOUS, Turkman Style
The Concourse of Birds, 1493
opaque colors and gold
4⅛ x 2⅞ inches
Bodleian Library, Oxford

Plate 82

ANONYMOUS, Turkman Style
*Two Men Greeting a Youth
on a Balcony*, ca. 1500
opaque colors and gold
3¼ x 5-1/16 inches
The Chester Beatty Library,
Dublin

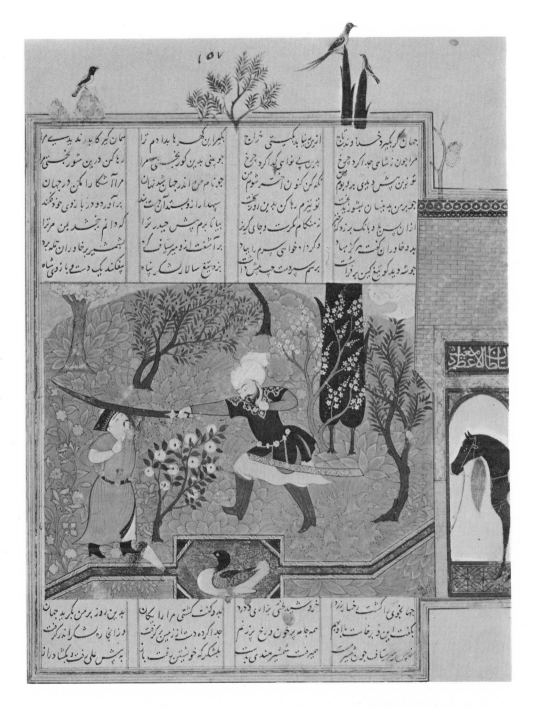

Plate 83
FARHAD
Mir Sayyaf Cuts off the Arm of the King of the East, 1477
opaque colors and gold
10½ x 13-11/16 inches
The Chester Beatty Library, Dublin

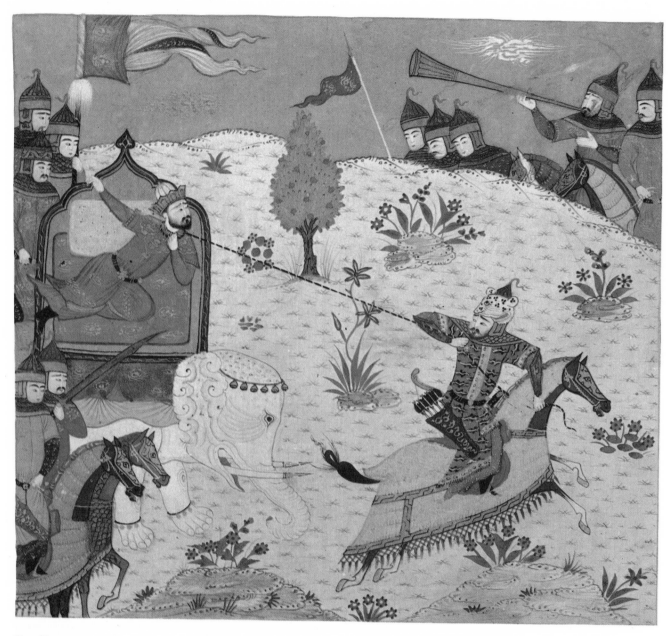

Plate 84
ANONYMOUS, Turkman Style • *Rustam Dragging the Khaqan from His White Elephant*, 1486 • 13¾ x 9½ inches • British Museum, London

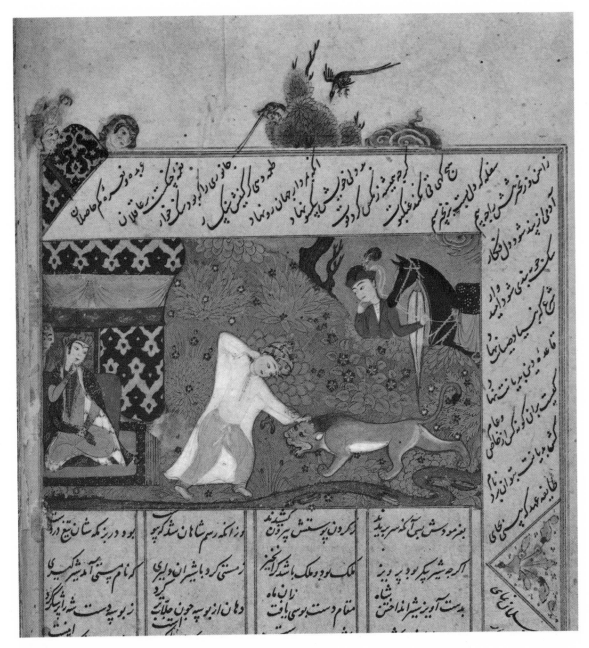

Plate 85

ANONYMOUS, Turkman Style · *Khusraw and the Lion*, ca. 1505—10 · opaque colors and gold, 4¾ x 4⅜ inches · India Office Library, London (Reproduced by Courtesy of the Secretary of State for Commonwealth Relations)

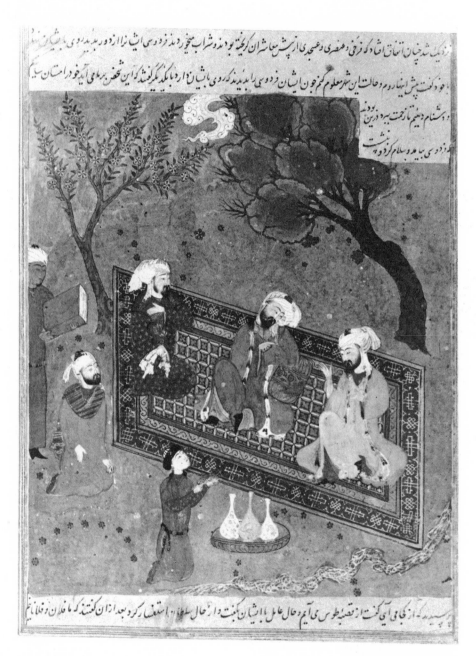

Plate 86

ANONYMOUS, Turkman Style
Presentation of the Shahnama *to*
Prince Baysunghur, 1494
opaque colors and gold
5⅝ x 4⅞ inches
Bodleian Library, Oxford

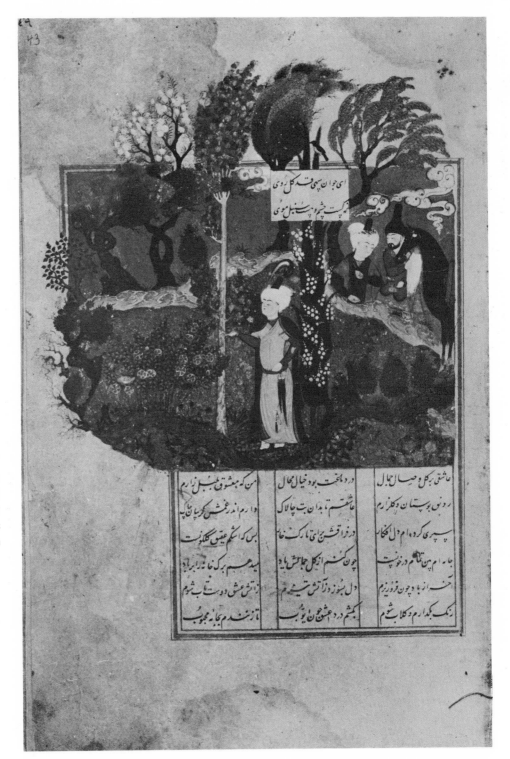

Plate 87
ANONYMOUS, Turkman Style
The Speech of the Rose, 1504–5
gouache on paper
12⅛ x 7⅞ inches
University Library, Uppsala, Sweden

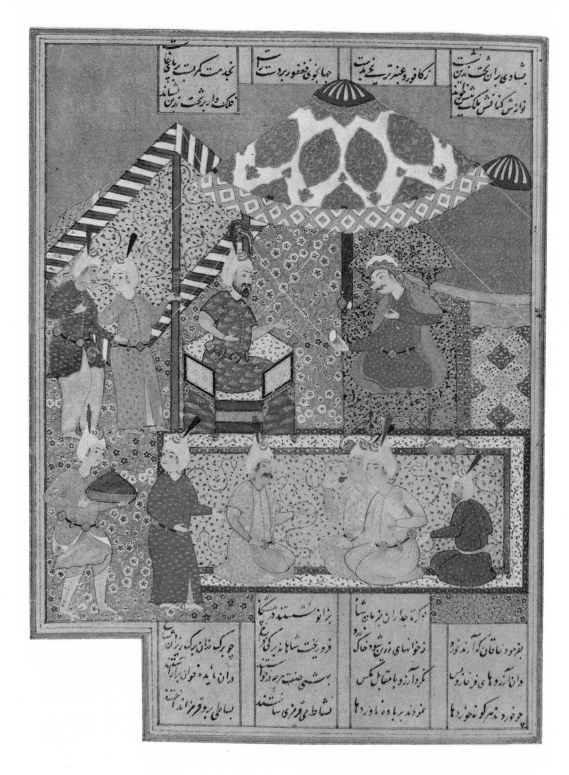

Plate 88

ANONYMOUS, Safawid
Style of Shiraz
*Iskandar Entertaining the
Khaqan*, ca. 1520
opaque color and gold
5½ x 7½ inches
Collection of Dr. and
Mrs. Schott, Gerrards Cross,
England (From the Collection
of the Late Mr. Paul Loewi)

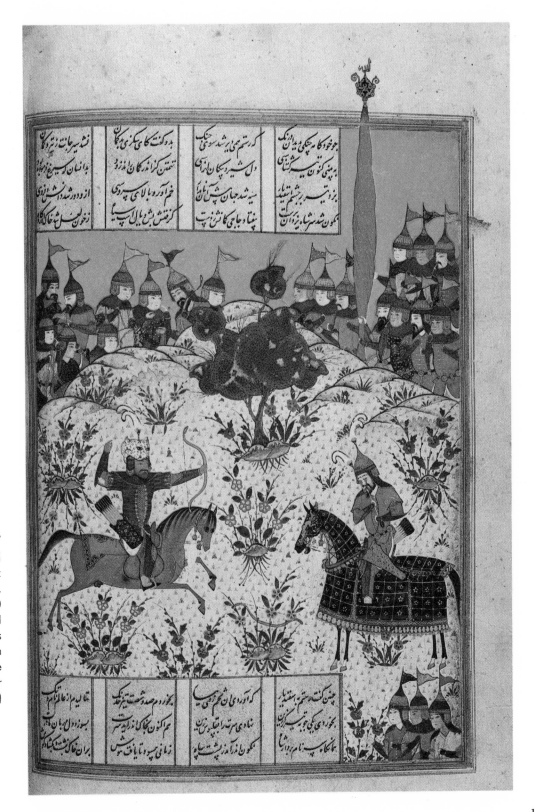

Plate 89
ANONYMOUS, Safawid
Style of Shiraz
Combat of Rustam and Isfandiyar,
1560
opaque colors and gold
10½ x 7½ inches
India Office Library, London
(Reproduced by Courtesy of the
Secretary of State for
Commonwealth Relations)

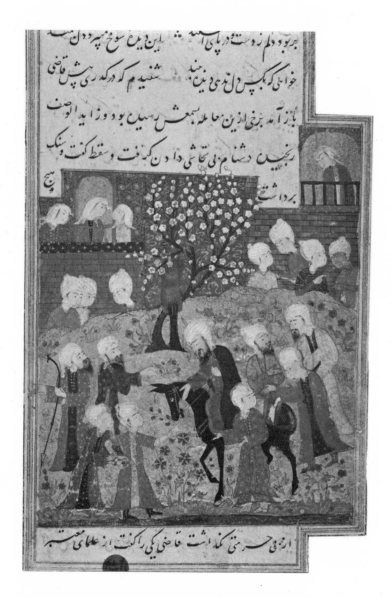

Plate 90

ANONYMOUS, Safawid Style of Shiraz
The Qazi and the Farrier's Daughter, 1513
4½ x 3¾ inches
British Museum, London

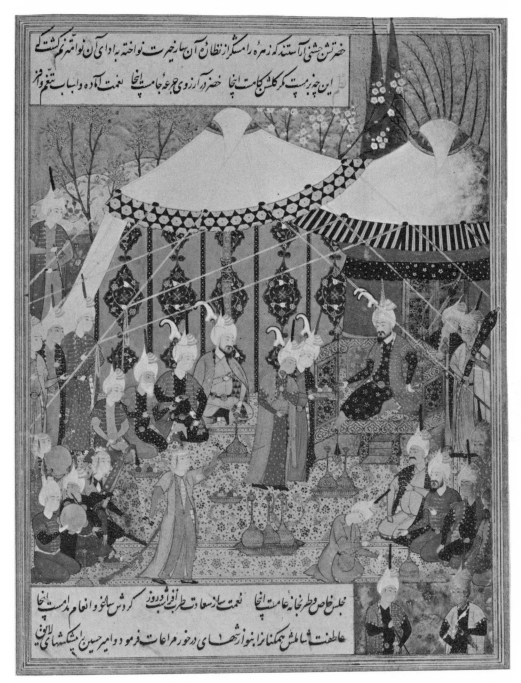

Plate 91

ANONYMOUS, Safawid Style of Shiraz • *Timur Enthroned, 1552* • 13¼ x 8¼ inches •
British Museum, London

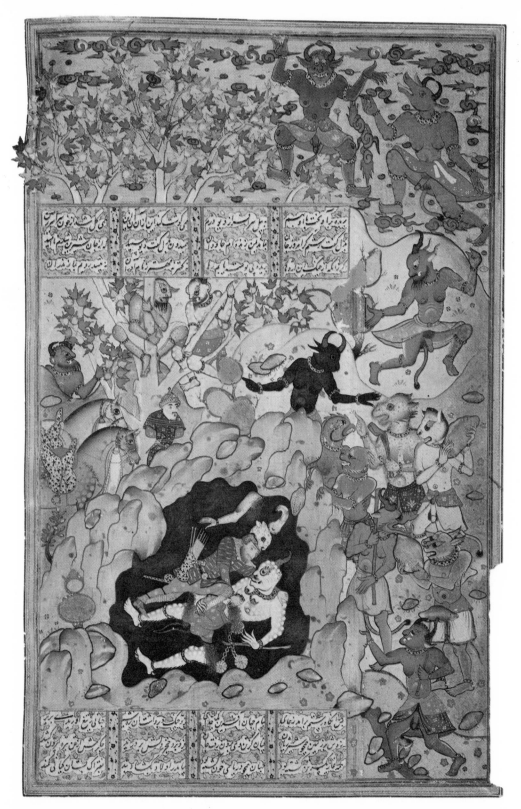

Plate 92

ANONYMOUS, Safawid
Style of Shiraz
Rustam and the White Demon,
ca. 1580
opaque colors and gold
13 x 8½ inches `
India Office Library, London
(Reproduced by Courtesy of
the Secretary of State for
Commonwealth Relations)

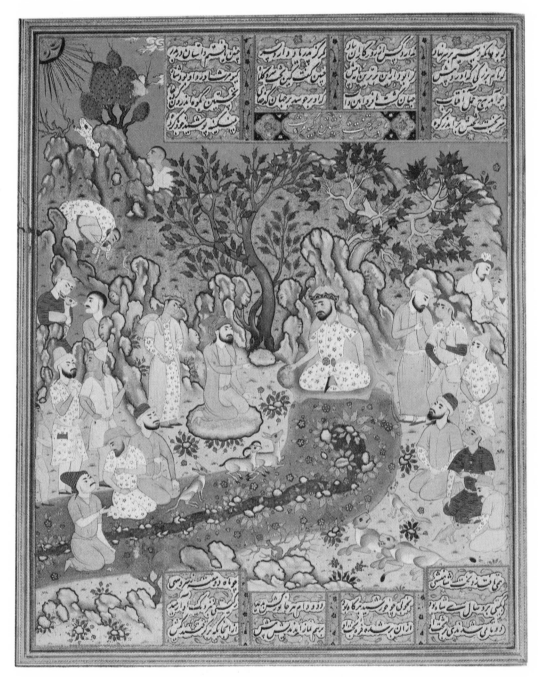

Plate 93

ANONYMOUS, Safawid Style of Shiraz · *Gayumarth, the First King, and His Court*, ca. 1590
opaque colors and gold, 12 x 9 inches · India Office Library, London (Reproduced by
Courtesy of the Secretary of State for Commonwealth Relations)

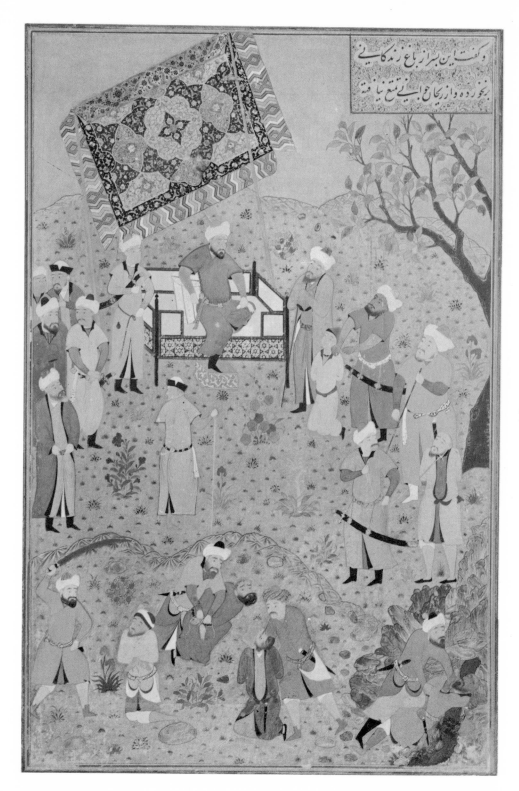

Plate 94

ANONYMOUS, Bukhara Style
The King and the Robbers, 1554
Bibliothèque Nationale, Paris

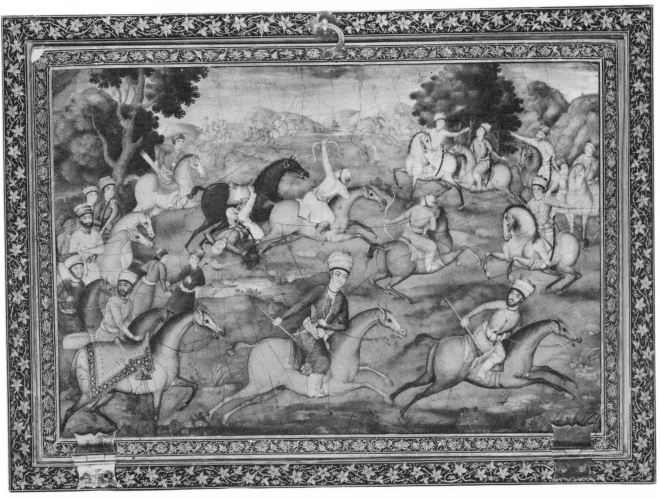

Plate 95
SADIQ • *Equestrian Sports* (mirror case), 1775 • papier-mâché, 10¼ x 7¼ inches • Victoria and Albert Museum, London

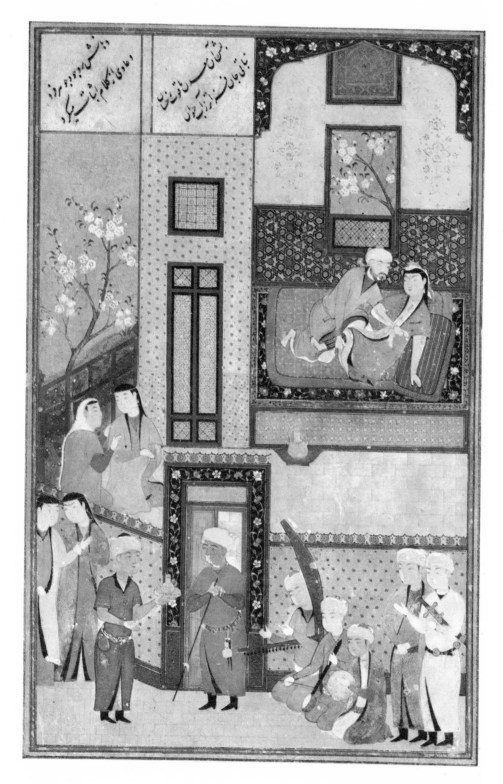

Plate 96

ANONYMOUS, Bukhara Style
The Marriage of Mihr and Nahid,
1523
color and gold on paper
7 5/8 x 4-13/16 inches
Courtesy of the Smithsonian
Institution, Freer Gallery of Art,
Washington, D.C.

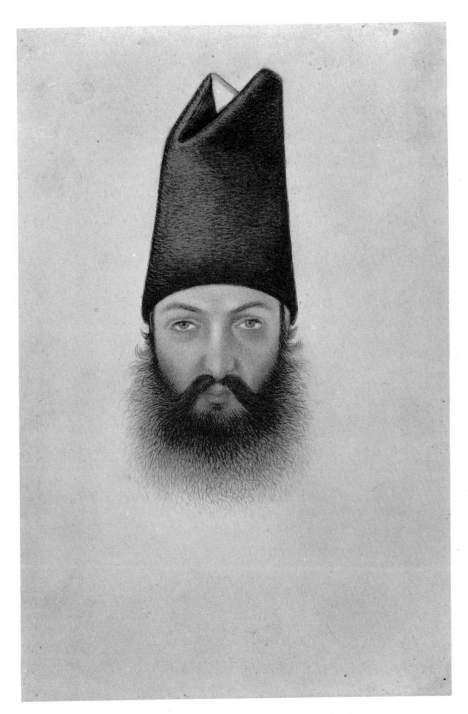

Plate 97
ABU 'L-HASAN GHAFFARI
Head of Khusraw Khan Kirmani,
ca. 1850—60
12 x 7¾ inches
British Museum, London

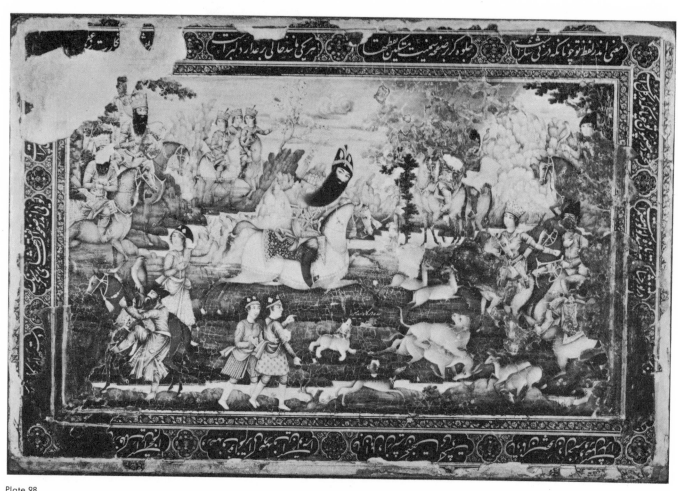

Plate 98

SAYYID MIRZA · *Fath'Ali Shah Hunting with His Family*, ca. 1825 · 14½ x 10 inches · British Museum, London

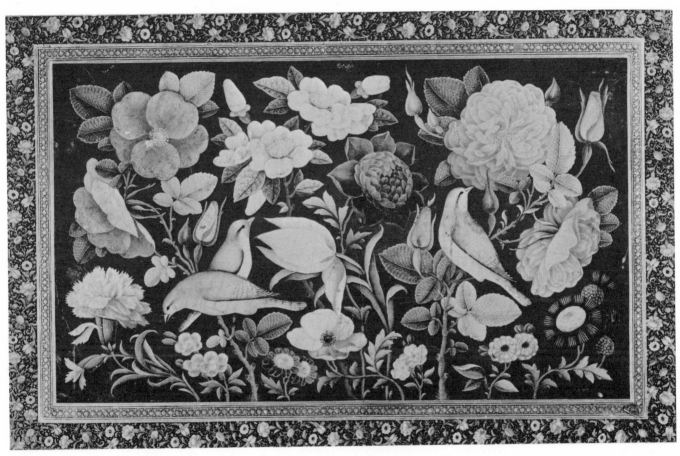

Plate 99

MIHR 'ALI · *Rose and Nightingale*, 1803 · watercolors on prepared papier-mâché, lacquered, 10 x 15⅞ inches · The Chester Beatty Library, Dublin

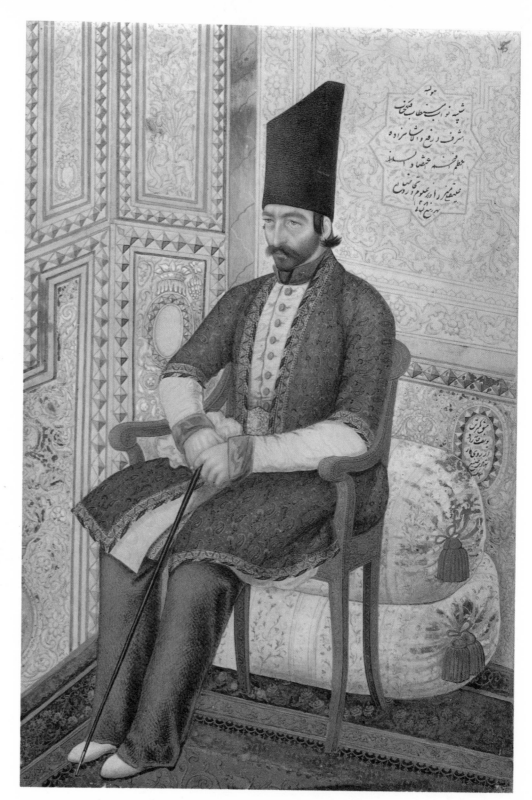

Plate 100
KHANAZAD YUSUF
Portrait of Prince Ali Quli Mirza,
1863
13½ x 8½ inches
British Museum, London

Notes on the Illustrations

SOME FAVORITE SUBJECTS OF ILLUSTRATION

We have already seen that Persian drawing (which, of course, includes colored drawings and miniature paintings) is, in the main, an art of book illustration. It is therefore essential to a proper understanding of it that we have some idea of the favorite subjects illustrated; Persian artists would have been horrified at the idea of anybody's professing appreciation of their works without having any idea of the stories behind them. A compendium of Persian history, legends, and popular stories is obviously beyond the scope of such a brief appendix as this, but we can at least take a quick look at the works of two great poets which have provided unfailing inspiration to Persian artists for more than six hundred years.

First is Firdawsi (*ca.* 931–1020), author of the *Shahnama* ("Book of Kings"), the national epic containing the traditional history of Persia down to the Arab conquest in the middle of the seventh century. It was completed after thirty years' labor about the year 1000, and presented to Sultan Mahmud of Ghazna, the poet's patron. In 1426 the whole poem of more than fifty thousand couplets was edited and the text standardized by Prince Baysunghur, the great Timurid bibliophile and *bon vivant* (Pl. 86).

The first part of the poem is completely mythical, beginning with Gayumarth, the first king, whose primitive subjects dressed in the skins of animals (Pl. 93), and going on to describe how the arts and crafts were taught under divine inspiration by his great-great-grandson King Jamshid (Pl. 20). Soon the scene shifts to the eastern province of Sistan, where a son was born to the hero Sam. Unfortunately the child Zal was born with white hair, said to be a sure sign of demon blood, so his father had the wretched infant exposed on a mountainside to be devoured by wild beasts. From this predicament, however, he was rescued by the miraculous bird Simurgh (Pl. 52). In due time Sam was informed in a dream that his son was alive, and received him back from the Simurgh. Later, Zal married Rudaba, daughter of the King of Kabul, and their son was Rustam (Pl. 78), the Persian national hero. While still a child he signalized his prowess by killing a mad elephant (Pl. 53).

Soon after this the foolish Kay Ka'us became king; he engaged in a rash expedition to conquer the northern province of Mazandaran, where he was captured and blinded, together with his whole army, by the terrible White Demon. News of the disaster somehow reached Persia, and Rustam embarked on the first of many rescue operations. After a journey full of adventures (Pl. 70) he slew the White Demon (Pl. 92), whose blood served to restore the sight of the king and his army. In due course Rustam was captivated by the beautiful Tahmina (Pl. 11), the daughter of a neighboring prince, and they had a son, Suhrab, whose tragic death at the hands of his father (Pl. 71) is the subject of Matthew Arnold's well-known poem.

Meanwhile the hopes of the kingdom were centered on Prince Siyawush, son of Kay Ka'us. But bad luck dogged him throughout his short life. His young stepmother attempted to seduce him and, her advances being indignantly rejected, accused him of outraging her. From this accusation he cleared himself by ordeal (Pls. 1, 22), and later married Firangis, daughter of King Afrasiyab of Turan, Iran's traditional foe. For a time they lived happily under Afrasiyab's protection, but jealous intrigues worked the downfall of the unlucky Siyawush, and in the end he was foully murdered. This crime unleashed a long war of revenge. Kay Khusraw, son of Siyawush, had by this time succeeded Kay Ka'us, but the expedition he sent against Turan wasted time and energy in reducing a border fortress whose defender, Farud, was killed by the Persian hero Bizhan (Pl. 76). The expedition then encountered disaster after disaster, and was only saved from extermination by the timely arrival of Rustam. The hero, at first fighting incognito on foot, defeated a number of Turanian champions in single combat (Pls. 23, 43) and even dragged the Khaqan, or Emperor of China, from his elephant (Pl. 84). In the ensuing general engagement the Persians were victorious.

One or two detached episodes follow, including the further adventures of the warrior Bizhan, who secretly married Manizha, another daughter of King Afrasiyab of Turan. He was discovered, and chained in a pit, but the faithful Manizha supplied him with food and eventually contrived to bring Rustam to his rescue (Pl. 10). Then comes the final and complete defeat of Afrasiyab, who was captured and beheaded by Kay Khusraw; Siyawush was avenged at last. His mission accomplished, Kay Khusraw vanished mysteriously in a mountain pool, and several of his paladins, who had accompanied him on this last pilgrimage, were lost in a blizzard (Pl. 69).

The vanishing of Kay Khusraw ends the first half of the *Shahnama,* and in the second half the characters and incidents begin to have a historical basis, especially after the death of

Rustam, which quickly followed his last great fight — unwillingly undertaken — against the gallant young Prince Isfandiyar. The latter was slain by a magic arrow given to Rustam by the Simurgh (Pl. 89). Soon after this the narrative embarks on the career of Alexander the Great, or Iskandar as he is called by the Persians, and this is the first point at which Firdawsi's work is overlapped by that of the other great poet, Nizami (ca. 1116–1200). The latter's *Khamsa*, or "Quintet" of romantic poems, has always run the *Shahnama* a close second as an inspiration to Persian painters. The exploits and travels of Iskandar occupy long passages of Firdawsi's poem and are also fully treated by Nizami in the *Iskandar Nama,* the last poem of his "Quintet." His relationships with lesser monarchs are exemplified by his entertaining the Khaqan, or Emperor of China (Pls. 33, 88), and by his sending a present of his own portrait to Queen Nushaba (Qaydafa in the *Shahnama;* Pl. 62), whom he later rescued from her Russian foes.

Firdawsi gives short shrift to the Parthians, but both he and Nizami accord very full treatment to the Sasanian kings Bahram Gur (Varanes V, 421–38) and Khusraw Parwiz (Chosroes II, 590–628). The former is, of course, "Bahram that great hunter" of Omar Khayyam, and after winning the crown by ordeal from between two raging lions (Pl. 5), he spent much of his time hunting, often in company with his mistress (Fig. 2; Pl. 35). His quarry was various, including the lion, the wild ass, and even the dragon (Pls. 26, 73), and these hunting expeditions gave him many opportunities of meeting and conversing with the humbler sort of his subjects, such as the shepherd who hanged his dog because it had allowed a wolf to steal lambs from the flock (Pl. 39). Nizami, whose poem on Bahram Gur is called the *Haft Paykar,* or "Seven Portraits," goes on to tell the story of the king's marriage to seven princesses, daughters of the Kings of the Seven Climates (Fig. 4), each of whom told him a story before retiring to a differently colored pavilion for each of the seven nights of a week (one such story is illustrated in Pl. 24). About a century after Bahram Gur, the throne was occupied by

Nushirwan (Chosroes I, 531–79), called "the Just," of whom, and of whose wise vizier, Buzurjmihr, many stories are told.

But Khusraw Parwiz (Pl. 32), whose long reign saw the Sasanian Empire at the peak of power (though on the very eve of its collapse under the fanatical onslaught of Islam), is the favorite subject of both poets: how he fell in love with a description of the Armenian Princess Shirin, how she fell in love with his portrait (Pl. 29), how he saw her bathing without knowing who she was (Pl. 9), how they met on various occasions (Pl. 7), and how Khusraw struck a prowling lion dead with his fist outside her tent at night (Pls. 58, 85)—these and other incidents of the story are illustrated again and again in Persian manuscripts of all periods. Nizami adds the tragic episode of poor Farhad, the sculptor and architect, who fell hopelessly in love with Queen Shirin (Pl. 6). For her he tunnelled a conduit through the solid rock of Behistun, having carved her figure on the rock face to inspire him (Pl. 77), only to fall to his death from the great crag on hearing a false report of Shirin's death sent by her jealous husband (Pl. 30).

Another of Nizami's *Khamsa,* the *Layla and Majnun,* tells a sad Arabian love story. Layla and Majnun were of different tribes, but fell in love while still at school, causing family quarrels and finally tribal warfare, and the lovers were kept apart. Majnun had always loved animals (Pl. 49), and being quite crazed with his love for Layla, fled to the desert and lived with the wild beasts. Occasionally he was visited by sympathetic friends and relations (Pl. 25), but only when he received news of his beloved's death did he return to civilization to expire on her tomb (Pl. 79). It was not until they reached Paradise that the star-crossed lovers were reunited (Pl. 75).

Such, in the barest outline, are the stories told by Firdawsi and Nizami of which illustrations will be found in this book. Other subjects are briefly sketched in the "Notes on the Illustrations." English or French translations of most of the works illustrated are available for those who wish to read the stories in full.

Figure 1. *The Owl, the Cat, the Mouse, and the Weasel, ca.* 1470. Gulistan Palace Library, Tehran; the *Kalila wa Dimna* ("Fables of Bidpai"), with 35 miniatures. See p. 20 for a discussion of the date. A mouse crept out of its hole in the roots of a huge tree to find a cat caught in a snare, observing at the same time that a weasel and an owl were watching for him. He therefore offered to release the cat, and when the owl and weasel saw the cat treating the mouse with consideration and affection they took themselves off. The mouse then released the cat, distracting its attention in order to withdraw to the safety of his hole once more.

Figure 2. *Bahram Gur Hunting,* 1527. Bibliothèque Nationale, Paris, Sup. turc 316, fol. 350b. The collected works of Mir 'Alishir Nawa'i (cf. Pls. 25, 28) in two volumes, with 6 miniatures, dated 932–33/1526–27; copyist, 'Ali Hijrani "at Herat."

Most of the illustrations seem to be the work of Bihzad's pupil Shaykhzada, but this one is very close to the work of Sultan Muhammad in his "intermediate" period—the period of the Cartier Hafiz (Pl. 34) in which he also collaborated with Shaykhzada—and may be attributed to him with some confidence. It seems highly probable that the central figure of Bahram Gur is a portrait of the recently deceased Shah Isma'il in which case the young prince in the foreground is no doubt intended for Tahmasp, whose age was about thirteen at the time.

Figure 3. *Girl in a Fur-Trimmed Hat,* 1602–3. The Hermitage, Leningrad, No. VP705. This is the earliest dated work bearing the signature "Riza-i 'Abbasi," and the style is very close to that of contemporary or slightly earlier drawings signed by or attributed to "Riza" and "Aqa Riza" (cf. Pl. 60). It is thus a powerful support to those who would identify Aqa Riza with Riza-i 'Abbasi. However, as indicated on p. 24, this thorny question is not yet finally settled.

Figure 4. *Bahram Gur and the Indian Princess Feasting by Night,* 1675. British Museum, London, Or. 2265, fol. 221b. From the same manuscript as Plate 35. This is one of the miniatures added to the manuscript by Muhammad Zaman in 1675. This artist had been sent to study painting in Italy by Shah 'Abbas II, and the thoroughly Europeanized style he brought back achieved immediate popularity and transformed the face of Persian painting and drawing. His technique was extremely accomplished, but the fusion of styles was not entirely happy. In addition to adding fresh miniatures of his own to this Nizami and the Chester Beatty *Shahnama* (see note on Pl. 52), Muhammad Zaman was unfortunately allowed to repaint some of the faces in the earlier miniatures.

Figure 5. *Portrait of Fath 'Ali Shah,* 1802. Windsor Castle, Royal Library, MS A/4, fol. 13a. The *Diwan* of Khaqan (Fath 'Ali Shah) with two portraits, the other being of the eunuch-king Aqa Muhammad, Fath 'Ali Shah's uncle and predecessor, and founder of the Qajar dynasty, dated 1216/1802; copyist, Muhammad Mahdi of Tehran, the Royal Scribe. This most luxurious copy of his own poems was sent by Fath 'Ali Shah as a gift to the Prince Regent (afterwards George IV) in 1812. Mirza Baba, the artist responsible for the whole decoration of the manuscript, including the portraits and lacquer covers, was *naqqash-bashi,* or painter-laureate, at the time. He was also successful as a painter in oils and in enamel on gold.

Plate 1. *The Fire-Ordeal of Siyawush,* 1370. Topkapi Sarayi Library, Istanbul, No. 1510, fol. 50a. The *Shahnama* of Firdawsi, with 12 miniatures, dated 772/1370; copyist, Mas'ud b. Mansur b. Ahmad "at Shiraz."

The colophon places this manuscript squarely in the period of Muzaffarid rule at Shiraz, and its illustrations are typical examples of the style practiced under that dynasty—a rather provincial version of the new style introduced by Ahmad Musa at Baghdad (see p. 18).

Plates 2 and 3. *Camp Scene,* 1402. Freer Gallery of Art, Smithsonian Institution, Washington, D.C., Nos. 32.34 and 32.35. The *Diwan* (Collected Poems) of Sultan Ahmad the Jalayrid, with 8 pages of lightly tinted marginal drawings, copied by Mir 'Ali, doubtless at Baghdad, in 805/1402.

These beautiful drawings have sometimes been written off as later additions, but a comparison with Plate 4 will show that they are, in fact, contemporary work of the highest quality and originality. Sultan Ahmad himself is said to have been a gifted amateur draughtsman, and it is not, perhaps, impossible that he himself added these informal embellishments to the margins of his own poems, which had been copied by the royal scribe Mir 'Ali, inventor of the *nasta'liq* script.

Plate 4. *Humay at the Castle of Humayun,* 1396. British Museum, London, Add. 18113, fol. 26b. Three poems by Khwaju Kirmani, with 9 miniatures, dated 798/1396; copyist, Mir 'Ali of Tabriz "at Baghdad." Khwaju Kirmani, who lived during the first half of the fourteenth century, was one of Nizami's many imitators, and his romantic poem of the loves of Humay and Humayun has many parallels with the latter's *Khusraw and Shirin* (cf. Pl. 7).

The splendor of this manuscript, the information in the colophon, and the fact that the miniatures are signed by the court artist Junayd, all point to that most enlightened prince Sultan Ahmad Jalayr as the patron. It was, of course, at the Jalayrid court of Baghdad that the true Persian style of drawing and painting had been evolved by Ahmad Musa half a century earlier.

Junayd is the earliest Persian artist to have left us signed work. The only thing known about him is that he was a pupil of Shams al-Din, who was himself a pupil of the great Ahmad Musa. Junayd is described as *ustad* ("master"), and *al-Sultani* ("in the royal service").

Plate 5. *Bahram Gur and the Lions,* 1397. The Chester Beatty Library, Dublin, Pers. 114, fol. 151b. *Shahnama* of Firdawsi, with 5 miniatures, copied by Muhammad b. Sa'id b. Sa'd al-Hafiz al-Qari, most probably at Shiraz, in 800/1397.

The style of these miniatures is directly derived from the Jalayrid school of Baghdad, but the figures have become less slim and attenuated. This variant of the early Timurid style may be associated with the court of Prince Iskandar Sultan at Shiraz and Yazd (cf. Pls. 8–11).

Plate 6. *The Sculptor Farhad before Queen Shirin,* ca. 1400–10. Smithsonian Institution, Freer Gallery of Art, Washington, D.C. No. 31.32. A fragmentary manuscript of the *Khusraw and Shirin* of Nizami, with 5 miniatures; copyist, 'Ali b. Hasan *al-Sultani* "at Tabriz."

The style of these beautiful miniatures is still very close to the Baghdad style of the Jalayrids, but without a precise date for the manuscript it is impossible to say for whom they were executed. Tabriz changed hands with bewildering rapidity during the years about 1400: having been captured by Timur from the Jalayrids in 1386, it was shortly afterwards sacked by Tuqtamish, Khan of the Golden Horde; Sultan Ahmad Jalayr retook it in 1406, only to be driven out again by the Turkman chief Qara Yusuf.

Plate 7. *Khusraw at Shirin's Palace,* ca. 1400–10. Smithsonian Institution, Freer Gallery of Art, Washington, D.C., No. 31.36, From the same manuscript as the preceding. Cf. Plate 4.

Plate 8. *Pastoral Life of the Mongols,* 1397. British Museum, London, Or. 2780, fol. 44b. A companion volume to that of Plate 5, containing various other epics. The present miniature is an illustration to the *Shahinshah Nama,* a rhymed chronicle of the Mongols down to the early fourteenth century.

Plate 9. *Khusraw Spies Shirin Bathing,* 1411. British Museum, London, Add. 27261, fol. 538b. *Compendium* or *Anthology,* made for Iskandar Sultan at Shiraz, with 49 minia-

tures and marginal drawings, dated 813–14/ 1410–11; copyists, Muhammad al-Halwa'i al-Jalali al-Iskandari and Nasr *al-katib*. In the latter part of this volume (foll. 403b–542b), marginal drawings are frequent. The miniature in the text depicts the zodiacal sign of Gemini, the Twins.

Plate 10. *Bizhan Rescued by Rustam*, 1411. British Museum, London, Add. 27261, fol. 298b. From the same manuscript as Plate 9.

Plate 11. *Tahmina Comes to Rustam's Chamber, ca.* 1410. Fogg Art Museum, Harvard University, Cambridge, Mass., No. 1939.225. A detached miniature in the same style as Plates 5, 8–10. Mr. Eric Schroeder, who first discovered and described it, has reconstructed the damaged inscription on the wall as a dedication to Iskandar Sultan, and ascribes it to the painter Pir Ahmad Baghshimali. It appears to be the only surviving fragment of a *Shahnama* made for the prince.

Plate 12. *The Jackal Kalila Visiting His Friend Dimna in Prison,* 1430. Topkapi Sarayi Library, Istanbul, No. 1022, fol. 56a. From the same manuscript as Plate 15. The two treacherous and self-seeking jackals, Kalila and Dimna, are the central characters throughout the first part of this classic. The latter was eventually imprisoned by King Lion for his part in compassing the death of the virtuous bull, Shanzaba, and was duly executed.

Plate 13. *Humay in the Fairy Palace,* 1427. Osterreichische Nationalbibliothek. Vienna, N.F. 382, fol. 10b. The *Humay and Humayun* of Khwaju Kirmani (cf. note on Pl. 4), with 3 miniatures, dated 831/1427; copyist, Muhammad b. Husam, called Shams al-Din Baysunghuri, "at Herat." The central figure is a portrait of Prince Baysunghur himself.

Plate 14. *The Poet Sa'di and a Friend in a Garden at Night,* 1426. The Chester Beatty Library, Dublin, Pers. 119, fol. 3b. The *Gulistan* of Sa'di, with 8 miniatures and *ex libris* of Baysunghur, dated 830/1426; copyist, Ja'far

Baysunghuri "at Herat." The subject comes from the introduction to the *Gulistan,* where Sa'di relates a conversation with a friend in a rose-garden during which the idea comes to him of composing a "rose-garden" (*gulistan*) of intermingled verses and anecdotes. The result was one of the most popular and renowned works of Persian literature.

This miniature shows how Baysunghur's artists enhanced the refinement and delicacy of the court style of Iskandar Sultan which they had inherited.

Plate 15. *The Crow Addressing the Wise Mouse,* 1430. Topkapi Sarayi Library, Istanbul, No. 1022, fol. 62a. The *Kalila wa Dimna,* or "Fables of Bidpai," with 25 miniatures and *ex libris* of Baysunghur, dated 833/1430; copyist, Muhammad b. Husam Shams al-Din Baysunghuri. The wise Mouse had freed a number of pigeons caught in a fowler's net, and the Crow, who had watched the episode, attempted to ingratiate himself. After some demurring, the Mouse accepted his friendship and also that of a Tortoise and a Deer, and the four friends then combined to outwit a hunter who had been pursuing the Deer.

Plate 16. *Prince Baysunghur Dallying with His Ladies,* 1426. I Tatti (Berenson Collection), Florence, *Anthology,* fol. 44a. This *Anthology,* with 7 miniatures, is dated 830/1426, and was copied by Muhammad b. Husam Shams al-Din Baysunghuri. The miniatures are rather freer in style than those in other manuscripts executed for Baysunghur, and as well as illustrating the poems they show the Prince hunting, playing polo, and, as here, relaxing in the company of his ladies.

Plate 17. *Muhammad Received by the Four Archangels,* 1436. Bibliothèque Nationale, Paris, Sup. turc 190, fol. 42a. From the same manuscript as Plate 19.

Plate 18. *Prince Baysunghur Hunting, ca.* 1430. Fogg Art Museum, Harvard University, Cambridge, Mass., No. 1952.5. Uncolored drawings are very rare at this period.

Plate 19. *Muhammad Sees the Tree of Jewels in Heaven,* 1436. Bibliothèque Nationale, Paris, Sup. turc 190, fol. 34a. The *Mi'raj Nama,* or "Book of Ascension," with 63 miniatures, copied in Uighur Turkish by Malik Bakhshi "at Herat"; dated 840/1436. The tradition of the Prophet's visit to Heaven and Hell, conducted by Gabriel and mounted on the human-headed steed Buraq, is founded on two passages in the Qur'an, but has been much elaborated, as in this poetical account. This celebrated manuscript contains the finest range of Herat painting of the post-Baysunghur period.

Plate 20. *Jamshid Teaching the Crafts,* 1469. The Chester Beatty Library, Dublin, Pers. 144, fol. 20a. A Persian translation of the (Arabic) *Annals* of Tabari, with 4 miniatures, dated 874/1469. Sober historians such as Tabari did not hesitate to accept the real existence of the legendary kings in the early part of the *Shahnama.* This fine large manuscript may well have been executed for Sultan Husayn Mirza, who later became the patron of Bihzad, at the very beginning of his reign.

Plate 21. *Prince and Ladies under a Paeony Branch, ca.* 1450. Museum of Fine Arts, Boston, No. 14.545. This is one of the very few surviving examples of a Persian painting on silk. It seems possible that the figures were added by a Persian artist to an original Chinese (Ming) painting of a paeony branch.

Plate 22. *The Fire-Ordeal of Siyawush, ca.* 1440. Royal Asiatic Society Library, London, No. 239, fol. 76a. The *Shahnama* of Firdawsi, with 31 miniatures, executed for Prince Muhammad Juki, a younger son of Shah Rukh, most probably at Herat. Cf. Plate 1. The illustrations to this manuscript are notable for their brilliant color schemes and the crisp drawing and execution that characterize the best Herat work.

Plate 23. *Combat of Rustam and Ashkabus, ca.* 1440. Royal Asiatic Society Library, London, No. 239, fol. 145b. From the same manuscript as the preceding.

The traditional representation of the national hero will have been noticed in Plate 10—the surcoat of tiger-skin and the leopard's head covering the helmet—and is seen again here. The leopard's head is always shown in works of the Shiraz and Turkman styles during the Timurid period, but this seems to be the only instance of it in a miniature of the Herat school. During the Safawid period it became universal.

Plate 24. *The Lady and the Banker,* 1485. The Chester Beatty Library, Dublin, Pers. 163, fol. 209b. The *Khamsa* of Amir Khusraw of Delhi (imitating that of Nizami), with 13 miniatures, dated 890/1485; copyist, Muhammad b. Azhar. This painting is the only one in the volume that can be attributed with any confidence to Bihzad, in view of the strong characterization, the masterly drawing and composition, and the highly original and effective color scheme.

The story is of a Banker from whom a thousand gold pieces were demanded by a Lady on account of his having enjoyed her favors in a dream. The dispute was referred to the King, who assumed the form of a parrot to give judgment, to the effect that, as the embrace had been illusory, the Lady must be content with the reflection of the money, which the Banker is here shown counting out before a mirror.

Plate 25. *Majnun Visited by Salim,* 1485. The John Rylands Library, Manchester, England, Turk MS 3, fol. 34a. This manuscript is one of a set of five containing the *Khamsa,* or "Quintet," of Sultan Husayn's eminent vizier (see p. 20), written in Chaghatay Turkish and dedicated to Prince Badi 'al-Zaman. All five volumes were brought back from Persia by Sir Gore Ouseley, Ambassador from George III to the Court of Fath 'Ali Shah. After his death this one somehow became separated from the others, which found their way to the Bodleian Library, Oxford.

Plate 26. *Bahram Gur and the Dragon, ca.* 1490. British Museum, London, Add. 25900, fol. 161a. The *Khamsa* of Nizami, with 19 miniatures, the text dated 846/1442. Only one miniature is contemporary with the text; four belong to the early Safawid period; and the remainder were executed at Herat towards the end of the fifteenth century. Of these latter several are signed by, or attributed to, Bihzad. One can easily see the master's hand in the sprightly vigor and impeccable execution of this little masterpiece.

Plate 27. *Funeral Procession and Builders at Work, ca.* 1485. Metropolitan Museum of Art, New York, No. 63.210, fol. 35a. The *Mantiq al-Tayr* ("Language of Birds") of Farid al-Din 'Attar, a mystical poem incorporating a number of anecdotes, with 8 miniatures (one dated 892/1487), the text dated 888/1483; copyist, Sultan 'Ali. See note on Plate 81.

This remarkable manuscript was formerly a pious legacy (*waqf*) by Shah 'Abbas I to the Safawid family shrine at Ardabil. Most of the contents of the shrine library were carried off by the Russians in the war of 1826 and are now in the Public Library at Leningrad. Four of the illustrations of this volume are contemporary with the text, and the other four were added apparently at the beginning of the reign of Shah 'Abbas I; one of the latter is signed by Habiballah of Mashhad (cf. Pls. 57, 59), and the illuminated double title-page was added at the same time, being signed by Zayn al-'Abidin of Tabriz (cf. note on Pl. 52). Of the four late fifteenth-century miniatures, all excellent examples of the court style of Herat under Sultan Husayn Mirza, the one here reproduced is the best. Its liveliness and originality, the superb drawing and characterization of the figures, make an attribution to Bihzad highly probable. It is a striking and allusive illustration to the story of a prince who built himself a palace; a small crevice in one of the walls was noticed by a sage, who warned the prince that the Angel of Death might enter through it.

Plate 28. *Shaykh 'Iraqi Overcome at Parting,* 1485. Bodleian Library, Oxford, Elliot 287, fol. 34a. The *Hayrat al-Abrar* (imitating the *Makhzan al-Asrar* of Nizami) by Mir 'Alishir Nawa'i, with 4 miniatures, dated 890/1485.

This manuscript is one of a set of five containing the *Khamsa,* or "Quintet," of Sultan Husayn's eminent vizier (see p. 20), written in Chaghatay Turkish and dedicated to Prince Badi' al-Zaman. Shaykh 'Iraqi (Fakhr al-Din Ibrahim) was a much-travelled thirteenth-century mystic poet.

The present miniature may well be the work of Qasim 'Ali who, according to Mirza Haydar Dughlat, was Bihzad's pupil and nearly equalled his master.

Plate 29. *Khusraw's Portrait Shown to Shirin,* 1495. British Museum, London, Or. 6810, fol. 39b. The *Khamsa* of Nizami, with 22 miniatures, dated 900/1495. This is the most important manuscript for the study of Bihzad and his school. The present miniature is by his teacher, Ruhallah Mirak of Khurasan, whose style, while of exquisite finish, retains some of the stiffness and formality of the mid-fifteenth century. He was made Director of Sultan Husayn's library, and was also known as an amateur athlete, boxer, and wrestler. He died in 1507.

Plate 30. *The Death of Farhad,* 1495. British Museum, London, Or. 6810, fol. 72b. From the same manuscript as the preceding. This miniature bears an attribution to Bihzad in the margin; the pathetic figure of the fallen Farhad and the lonely rock in its barren landscape are very well shown.

Plate 31. *Youth and Old Age,* 1524. Smithsonian Institution, Freer Gallery of Art, Washington, D.C., No. 44.48, fol. 3a. An *Anthology* —almost a luxurious autograph-book—to which six of the foremost calligraphers of the period contributed. It may perhaps have been prepared as a gift from the Royal Library staff to the young Shah Tahmasp on his accession, in which case the contribution of this charming little miniature by Bihzad, the veteran Director, is particularly appropriate. It is stated to be his work in the introductory text of the manuscript, and this statement may be accepted, though some authorities have found the work not up to the master's classic standards. But we must remember that

by this time Bihzad must have been an old man in his middle seventies.

Plate 32. *Khusraw Enthroned,* 1525. Metropolitan Museum of Art, New York, No. 13.228.7, fol. 64a. The *Khamsa* of Nizami, with 15 miniatures, dated 931/1525; copyist, Sultan Muhammad Nur. This manuscript is said to have been given by Muhammad 'Ali Shah, at a time of financial embarrassment early in the present century, to one of his ladies who had importuned him for money to buy a new dress. It turned up in a dingy room in a small Paris hotel, in the shabby trunk of an Armenian dealer, from whom it was bought by its first European owner, Dr. F. R. Martin, for the equivalent of about $700.

Shaykhzada, to whom most of the miniatures may be confidently attributed, was a native of Khurasan and a pupil of Bihzad—whose style he seems to have followed more closely than most of his fellow pupils, such as Muzaffar 'Ali (Pl. 35). As we have seen, he collaborated with Sultan Muhammad on at least two occasions (Fig. 2; Pl. 34).

Plate 33. *Iskandar Entertained by the Khaqan,* 1525. Metropolitan Museum of Art, New York, No. 13.288.7, fol. 321b. From the same manuscript as the preceding.

Mir Musawwir, to whom this miniature may be attributed on grounds of style, was a native of Badakhshan and at one time Librarian to Mir 'Alishir Nawa'i; he is also said to have been a pupil of Bihzad. Under Shah Tahmasp, he contributed to the Rothschild *Shahnama* and the British Museum Nizami, succeeding Sultan Muhammad as director of the royal studios. He worked with Mirak on mural paintings for Prince Bahram Mirza, and was also noted as a portrait painter. He visited Turkey and later, accompanied by his son Mir Sayyid 'Ali, travelled to India (see note on Pl. 36).

Plate 34. *The Triumph of Bacchus, ca.* 1530. Private Collection, Cambridge, Mass. The manuscript of the *Diwan* of Hafiz from which this miniature is reproduced was for a long time in the collection of M. Louis Cartier of Paris, and is hence usually known as the Cartier Hafiz. It is undated, but was executed for Prince Sam Mirza, a younger brother of Shah Tahmasp. Of the four (formerly five) miniatures it contains, three are by Sultan Muhammad and one (and the missing one) by Shaykhzada. On this one the signature of Sultan Muhammad appears over the doorway on the left of the picture.

This remarkable composition, which admirably illustrates Sultan Muhammad's marvellous draughtsmanship and technique, his vigor, originality, and keen sense of humor, clearly demonstrates that he, at all events, did not put any mystical interpretation on the convivial odes of the Persian Anacreon. Everybody in the picture is drunk, including the angels on the roof.

Sultan Muhammad, the greatest artist of the Safawid period, was born at Tabriz, probably about 1480. Judging from the style of his earliest authenticated works, he may have received his basic training in the Turkman style, and soon after the establishment of the new dynasty we find him giving the young Prince Tahmasp instruction in painting. After the latter came to the throne in 1524, Sultan Muhammad contributed to a series of magnificent manuscripts, beginning with the Rothschild *Shahnama* (*ca.* 1525–26) and ending with the British Museum Nizami (1539–43). (He probably died about 1545.) During this period his style, at first bold, original, *farouche,* was gradually smoothed out into the highly accomplished academic manner of the British Museum Nizami. This may have been due to persuasion or pressure from the king and his intimate friend, the academic painter Mirak (not to be confused with Bihzad's teacher of the same name).

Plate 35. *Bahram Gur Hunting the Wild Ass, ca.* 1540. British Museum, London, Or. 2265, fol. 211a. The *Khamsa* of Nizami, with 16 miniatures (of which two were added by Muhammad Zaman in 1675—see Fig. 4), dated 945–49/1539–43; copyist, Shah Mahmud of Nishapur. This luxurious volume, the last made for Shah Tahmasp before he turned his back on painting and became a religious bigot, must be one of the half-dozen finest manuscripts in the world.

Muzaffar 'Ali, to whom this picture bears a contemporary attribution, was a nephew and pupil of the great Bihzad, to whom he was considered nearly equal. He was skilled alike in miniature painting and drawing, mural painting, lacquer work, and calligraphy, and lived on until 1576.

Plate 36. *Camp Scene, ca.* 1540. Fogg Art Museum, Harvard University, Cambridge, Mass., No. 1958.75. This splendid composition, which was formerly cut in two across the middle to fit the album of some unspeakable former owner, may have been intended as an illustration of the family conference between the tribal elders in Nizami's *Layla and Majnun.* If so, there can be little doubt that it was destined for the British Museum manuscript from which Plate 35 is reproduced. Mir Sayyid 'Ali, the artist to whom it bears a contemporary attribution, did actually contribute to this manuscript a camp scene (fol. 157b) illustrating another episode in the same poem, and it may be that two such similar illustrations by the same artist were considered excessive, and that consequently it was decided not to include this miniature in the manuscript.

Mir Sayyid 'Ali was perhaps the most observant and realistic among Shah Tahmasp's court artists. He and his father, Mir Musawwir (Pl. 33), accompanied the Emperor Humayun to India in 1544, and became the founders of the Mughal school.

Plate 37. *Night Entertainment on a Terrace, ca.* 1540. The Chester Beatty Library, Dublin, Pers. 236, fol. 59b. The *Bustan* of Sa'di (a work very similar to the *Gulistan*—see note on Pl. 14), with 4 miniatures; undated, but the calligraphy ascribed to Sultan 'Ali (*ca.* 1500).

The other three miniatures in this manuscript date from the end of the sixteenth century, but this one is about half a century earlier, and may be attributed on grounds of style to Mirza 'Ali, who was a son of Sultan Muhammad (Fig. 2; Pl. 34) and a pupil of Bihzad and Mirak. He thus grew up in the Royal Library at Tabriz and absorbed all the

best teaching it had to offer. He became, in his turn, the teacher of Kamal, a notable artist of the mid-sixteenth century.

Plate 38. *An Angel Descending upon Yusuf,* 1540. The Chester Beatty Library, Dublin, Pers. 251. fol. 151b. The *Yusuf and Zulaykha* of Jami, with 5 miniatures, dated 947/1540. The biblical story of Joseph and Potiphar's wife (Yusuf and Zulaykha) also occurs in the Qur'an, and was treated at length by the poet Jami in what became one of the most popular of Persian romantic poems. The miniatures in this charming little manuscript are on a modest scale, but of splendid quality, and three of them—including this one—may be attributed to Mirza 'Ali (see preceding note).

Plate 39. *Bahram Gur and the Shepherd who Hanged His Dog,* ca. 1540–50. Museum of Fine Arts, Boston, No. 14.589. A preliminary drawing for an illustration to one of the anecdotes in the *Haft Paykar* of Nizami which may possibly have been intended for the great Nizami manuscript of Shah Tahmasp in the British Museum (Pl. 35). The drawing bears an almost obliterated attribution; all that can be made out is *"'amal i ustad Mir...,"* ("work of the master Mir..."). This might stand for Mir Musawwir, Mir Sayyid 'Ali, Mirak, or Mirza 'Ali. Mir Sayyid 'Ali has been suggested on the grounds of his apparent predilection for scenes of encampment and rural life (see note on Pl. 36), but the figures and faces do not look like his. Perhaps Mirak may be the most likely candidate.

Plate 40. *Pastoral Scene,* 1578. Louvre, Paris, No. 7111. The attribution to Muhammadi and the date (986/1578) which this fine drawing bears are perfectly credible. Although it does not appear to illustrate any particular story, it is full of well-observed detail and shows a sympathetic feeling for country life. Muhammadi was the foremost artist during the last years of Shah Tahmasp, and is said to have been a son of Sultan Muhammad and a native of Herat (it will be remembered that Sultan Muhammad spent some time at Herat about 1526–27, working on the Paris Nawa'i

manuscript—see note on Figure 2—and possibly Muhammadi was born there at that time). He has left a self-portrait which is in the collection of the Museum of Fine Arts, Boston (No. 14.583). What may perhaps be some of his early work is found in the Jami manuscript at the Smithsonian Institution, Freer Gallery of Art (cf. Pls. 45, 48). He excelled in the depiction of young people of both sexes (Pl. 46) and in the decoration of lacquer bookbindings.

Plate 41. *Seated Youth with Parakeet,* ca. 1575. Smithsonian Institution, Freer Gallery of Art, Washington, D.C., No. 37.23. Shaykh Muhammad, the artist of this delightful drawing, is described as "a man of wit, of charming appearance, and an agreeable companion." He was a native of Shiraz, and worked at Sabzawar in Khurasan, at Tabriz, and at Qazwin; his teacher was the painter Dust i Diwana. Shaykh Muhammad worked at first for Prince Ibrahim Mirza (cf. Pls. 45, 48) and later joined the library staff of Shah Isma'il II (1576–77); he died, probably about 1600, in the service of Shah 'Abbas I. He is said to have imitated the Chinese style and to have been the first to introduce European pictures into Persia.

Plate 42. *Mounted Prince Attacked by a Lion,* ca. 1570. Walters Art Gallery, Baltimore, No. 10.747. This drawing bears the signature of Siyawush, who began his long career as a page at the court of Shah Tahmasp. The king noted his natural talent for painting, and arranged for him to be properly taught, so that he was added to the strength of the Royal Library staff by Isma'il II and continued in the royal service until his death during the reign of 'Abbas I. This drawing is an excellent example of the combination of delicacy and vigor that marks his work and is especially noticeable in his line drawings.

Plate 43. *Rustam Lassoing Kamus,* ca. 1576. Collection of Dr. and Mrs. Schott, Gerrards Cross, England (Formerly Paul Loewi Collection). A detached miniature from a large and sumptuous manuscript of the *Shahnama,* most

probably made for Isma'il II at the time of his accession. Other miniatures from the same volume are scattered in various public and private collections, mostly in America (and five in the Chester Beatty Library, Dublin, Pers. 256), and many of them bear small attributions, contemporary and authentic, to various court artists. This miniature is attributed to Siyawush the Georgian (see preceding note).

Plate 44. *Seated Princess,* ca. 1550. Fogg Art Museum, Harvard University, Cambridge, Mass., No. 1958.60. The date of this charming work, formerly in the Cartier Collection, must be about 1550, but it does not seem possible to attribute it to any particular artist. It is a comparatively early example of the separate paintings and drawings—intended for the albums of connoisseurs and not for the illustration of manuscripts—whose production gradually increased through the sixteenth century.

Plate 45. *Yusuf Tending the Flock,* ca. 1560. Smithsonian Institution, Freer Gallery of Art, Washington, D.C., No. 46.12, fol. 110b. The *Haft Awrang* ("Seven Thrones"), a collection of seven romantic poems by Jami, with 28 miniatures, dated 963–72/1556–65, and dedicated to Prince Ibrahim Mirza—a son of Shah Tahmasp—who was governor of Mashhad at the time; copyists, Malik al-Daylami, Shah Mahmud of Nishapur, 'Isha b. 'Ishrati, Rustam 'Ali, and Muhibb 'Ali "at Mashhad." This magnificent manuscript, which was formerly in the library of the Ardabil Shrine (see note on Pl. 27), was the masterpiece of the library staff of one of the most aesthetically cultivated Persian princes of any period. He was, alas, done to death on February 24, 1577, along with six other princes—one of them a two-year-old child—by his unnatural brother Isma'il II. Ibrahim Mirza was himself a skilled poet, artist, musician, and calligrapher.

The miniatures in this manuscript admirably illustrate the transition from the court style of Tabriz to that of Qazwin with its increasing emphasis on naturalism and bold draughtsmanship. For the subject, see note on Plate 38.

Plate 46. *Lovers, ca.* 1575. Museum of Fine Arts, Boston, No. 14.588. The attribution to Muhammadi (see note on Pl. 40) may be confidenty accepted, and this delightful picture well exemplifies his masterly sureness of line, clean-cut execution, and delicacy of feeling.

Plate 47. *Man Playing the Panpipes, ca.* 1580–90. Museum of Fine Arts, Boston, No. 14.610. This is so close in style and feeling to the work of Muhammad Mu'min that it must be by his hand, though in his catalogue of the Boston collection Coomaraswamy attributed it to the Mughal artist Aqa Riza Jahangiri (to be clearly distinguished from the Persian Aqa Riza, Plates 51, 55, 56).

Plate 48. *The Heavenly Ascent of the Prophet Muhammad, ca.* 1560. Smithsonian Institution, Freer Gallery of Art, Washington, D.C., No. 46.12, fol. 275a. From the same manuscript as Plate 45. For the subject, see note on Plate 19. The Heavenly Ascent (*mi'raj*) is often alluded to in the prologues to romantic poems, and is thus a fairly common subject of illustration in manuscripts of Nizami, Jami, Hilali, and others.

Plate 49. *Majnun Ransoming the Antelope,* 1569. Gulistan Palace Library, Tehran; the *Silsilat al-Dhahab* ("The Chain of Gold") of Jami, a religious poem containing many anecdotes, composed in 1485. This copy, with 14 miniatures, is dated 977/1569–70, and is in the handwriting of Babashah, a native of Isfahan and a calligrapher of high repute. Cf. Plates 45, 48.

An incident in the story of Majnun: one day he came upon a hunter about to kill an antelope caught in a snare, and gave his horse in exchange for the poor creature's life.

Plates 50 and 51. *A Hawking Party in the Mountains, ca.* 1580. Metropolitan Museum of Art, New York, No. 12.223.1 (left hand), and Museum of Fine Arts, Boston, No. 14.624 (right half). This sumptuous composition, originally intended, no doubt, for the double-page frontispiece of a manuscript, is typical of the best court art of the late sixteenth century:

its elegant, attenuated youths with their round faces and rather elongated necks; its emphasis on strong, sinuous line; the richness of its landscape backgrounds; and its impatience with the confinement of the ruled margin. Such drawings of princely hunts and picnics were especially fashionable at this time. It is not possible to ascribe this picture to any particular artist.

Plate 52. *The Simurgh Carrying Zal to Her Nest, ca.* 1590. The Chester Beatty Library, Dublin, Pers. 277, fol. 12. The *Shahnama* of Firdawsi (a fragment only) with 16 miniatures —two of which were added by Muhammad Zaman in 1676—and illumination signed by Zayn al-'Abidin of Tabriz (cf. note on Pl. 23). The superb copy of the national epic of which only this fragment seems to have survived, was almost certainly executed for 'Abbas I shortly after his accession.

The artist of the present miniature, which is perhaps the most impressive of the whole set, cannot be identified at present, but it is clear that he was one of the older generation and had probably been a member of the Royal Library staff under Isma'il II.

Plate 53. *Rustam and the Mad Elephant, ca.* 1590. The Chester Beatty Library, Dublin, Pers. 277, fol. 13. From the same fragmentary manuscript as the preceding.

In contrast to Plate 52, this miniature is the work of one of the younger court artists practicing the new style, as can be seen from the manner of drawing the faces and figures, and a comparison with the work of Aqa Riza, knowing as we do that he was in the royal service from the beginning of the reign of 'Abbas, inevitably suggests an attribution to him. Qazi Ahmad tells us that he was the foremost artist of his time, with an appointment at court, but adds that later in life he got into bad company and occupied himself with wrestling.

Plate 54. *Girl with a Fan, ca.* 1590. Smithsonian Institution, Freer Gallery of Art, Washington, D.C., No. 32.9. This drawing illustrates the new trend in face and figure

drawing introduced by Aqa Riza (whose signature appears on this picture) about the beginning of the reign of 'Abbas I: the body and limbs fill out, the face becomes plumper and more childishly engaging, and the lines in general become more calligraphic, though naturally this latter characteristic can be seen better in uncolored drawings.

Plate 55. *Seated Youth, ca.* 1600. Pierpont Morgan Library, New York, M. 386. This album picture shows the trend of taste at the Safawid court when 'Abbas I was firmly established on the throne. The exquisitely languid young man in his enormous, and no doubt highly fashionable, turban reminds us of the "Ganimed boies" observed at the Persian court by Sir Thomas Herbert in 1627. The identity of the artist is not established.

Plate 56. *Young Man Seated under a Tree,* 1637. Private Collection, London. The drawing is signed by Muhammad Yusuf (his usual sobriquet of al-Husayni has been erased and altered to 'Abbasi) and dated 1047/1637. His style, modelled on that of Riza-i 'Abbasi, is very similar to that of Muhammad Qasim, with whom he collaborated on a number of occasions (cf. note on Pl. 62), and his flowing and harmonious line is well illustrated in the present example.

Plate 57. *Seated Lady, ca.* 1600. Private Collection, London. The signature is almost obliterated, but there is little doubt that it is that of Habiballah of Mashhad, and this is borne out stylistically by the drawing of the face. This drawing shows Habiballah's mastery of delicate, yet firmly flowing line, only a little inferior to that of Aqa Riza. It seems difficult to accept the view recently put forward that his style was provincial and little influenced by the new trends in the capital.

Plate 58. *Khusraw and the Lion,* 1632. Victoria and Albert Museum, London, L. 1613–1964. This miniature was extracted from the well-known manuscript of Nizami's *Khusraw and Shirin* in the Victoria and Albert Museum (No. 364–1885) by its former owner, but has

recently been reunited with the parent volume. All nineteen miniatures are signed in the lower margin by Riza-i 'Abbasi, and one of them is dated 1042/1632. Several authorities have cast doubts on their authenticity but, although nobody would be tempted to rank the majority of them with the artist's best work, at least three (this one and foll. 47a and 138b) are well up to standard, and there seems no reason, stylistic or otherwise, why all should not be by the same hand. The manuscript is obviously a royal one; the copyist was 'Abd al-Jabbar, a well-known scribe in the royal service, and the exceptionally luxurious binding is signed by Muhammad Muhsin of Tabriz. Cf. Plate 85.

Plate 59. *Young Huntsman Carrying His Gun,* ca. 1600. Staatliche Museen (Islamisches Museum), Berlin, No. I.4589, fol. 11b. Habiballah of Mashhad, whose signature appears on this drawing, was taken to Herat by Husayn Khan Shamlu, Governor of Qum, where Habiballah had been living, and from there entered the service of 'Abbas I. He settled at Isfahan and became a court painter of high repute (cf. note on Pl. 27).

Plate 60. *Seated Youth, ca.* 1600. Metropolitan Museum of Art, New York, No. 55.121.39. Another superbly elegant figure by Aqa Riza, whose signature appears towards the bottom. For the negligently worn fur-lined coat cf. Plate 55; one suspects a passing whim of fashion among the young exquisites of Isfahan.

Plate 61. *Lady Counting on Her Fingers,* ca. 1630. Bibliothèque Nationale, Paris, Sup. pers. 1572, p. 5. A fine album picture, and very typical of the mature style of Riza-i 'Abbasi, whose signature and other written particulars have been erased.

Plate 62. *Iskandar Preparing His Portrait for Queen Qaydafa,* 1648. Windsor Castle, Royal Library, MS A/6, fol. 498a. The *Shahnama* of Firdawsi, with 148 miniatures, dedicated to the nobleman Qarajaghay Khan and dated 1058/1648; copyist, Muhammad Hakim al-Husayni. Among seventeenth-century copies

of the national epic, this manuscript is second only to the almost contemporary Leningrad copy (Public Library No. 333) in magnificence. It is illustrated by Muhammad Qasim and Muhammad Yusuf (see note on Pl. 56), two of the best followers of Riza-i 'Abbasi, but the double-page frontispiece is signed by Malik Husayn of Isfahan, an artist of the older generation. The present miniature is almost certainly by Muhammad Qasim; his style is easy and elegant, following that of Riza-i 'Abbasi fairly closely. The volume was sent as a gift to Queen Victoria by the wife of Kamran Shan, Prince of Herat, in 1841.

Plate 63. *The Worship of Fire in India,* ca.1650. The Chester Beatty Library, Dublin, Pers. 268, fol. 8a. A copy of *Suz wa Gudaz* ("Burning and Melting"), a romantic poem by Muhammad Riza Naw'i, with 10 miniatures. In the absence of signature or attribution, the miniatures in this beautiful little volume may be confidently ascribed on stylistic grounds to Muhammad Qasim. The theme of the poem, which was written in India at the request of Prince Daniyal, son of the Mughal Emperor Akbar, was an incident during the latter's reign when a Hindu widow insisted on carrying out the horrible practice of *sati* by burning herself on her husband's funeral pyre. The poem seems to have been very popular in Persia in the middle of the seventeenth century; two other contemporary copies of almost equal magnificence are in the Bibliothèque Nationale, Paris (Sup. pers. 769) and the Chester Beatty Library (Pers. 269), and detached miniatures have survived from two others.

Plate 64. *Girl Arranging Her Hair, ca.* 1610–20. Victoria and Albert Museum, London, I.S. 133–1964, fol. 46a. This picture is in the "Clive Album," said to have been brought from India by the first Lord Clive (d. 1774). Its contents are Indian for the most part, but it also contains a few seventeenth-century Persian works of very high quality (see also Pl. 68) The artist is unidentified.

Plate 65. *Lovers Served with Wine by an Attendant,* ca. 1620. Seattle Art Museum, Washington. This brilliant work, which both in drawing and color is among the best Riza-i 'Abbasi ever produced, seems to belong to his earlier period before his style had hardened into the rather rigid and mannered formula characteristic of his maturity.

Plate 66. *Girl in a Furred Bonnet, ca.* 1650–60. Musée Guimet, Paris, No. 7128. Muhammad 'Ali, by whom this little drawing is signed, was a son of Malik Husayn (see note on Pl. 62) and thus a younger contemporary of Muhammad Qasim and Muhammad Yusuf; like them he was an inheritor of the style of Riza-i 'Abbasi. Although not their equal in reputation or achievement, he was an artist of some originality whose work is recognizable by a rather individual facial type of which this drawing gives a good example.

Plate 67. *A Camel,* 1678. Private Collection, Cambridge, Mass. Long and flamboyant inscriptions are often found on the drawings of Mu'in, the best pupil of Riza-i 'Abbasi. Here he tells us that this drawing is after a design by Bihzad, and that he finished it on the night of Wednesday, the 28th of Shawwal, 1089 (December 13, 1678). Mu'in developed an individual variation of his master's style which can be better seen in Plate 69. He had a long working life, covering the whole of the second half of the seventeenth century, and in such unconventional works as this shows himself to be an original draughtsman of ability and wit. In his more normal miniature paintings he maintained the tradition of his master's style in the face of the Italianizing innovations introduced by Muhammad Zaman (Fig. 4) during the last quarter of the century.

Plate 68. *Lovers,* 1647. Victoria and Albert Museum, London, I.S. 133–1964, fol. 44a. This picture is in the "Clive Album," said to have been brought from India by the first Lord Clive (d. 1774). Its contents are Indian for the most part, but it also contains a few seventeenth-century Persian works of very high quality. This scene of mild debauchery

is typical of mid-seventeenth-century taste. It is the work of Afzal al-Husayni, sometimes called Mir Afzal Tuni, another noteworthy artist in the tradition of Riza-i 'Abbasi. In Afzal's hands the master's mannerisms became still more exaggerated: the long, rather close-set eyes, the strongly drawn and rather mechanical drapery, and the languid postures. Afzal was one of the artists who worked on the great Leningrad *Shahnama* of 'Abbas II (cf. note on Pl. 62).

Plate 69. *The Paladins in the Snow*, 1649. Fogg Art Museum, Harvard University, Cambridge, Mass., No. 1941.294. A detached miniature from a copy of the *Shahnama* dated 1059/1649, with miniatures signed by Mu'in. He illustrated another *Shahnama*, dated 1066/1655, now in the Chester Beatty Library, Dublin (Pers. 270), and contributed to at least one more. The seventeenth-century style of Isfahan is not really suited to epic illustration, but several of Mu'in's *Shahnama* illustrations, such as this very original conception of a rare subject, are nevertheless successful and effective.

Plate 70. *Rustam Slaying the Demon Arzhang*, ca. 1435. Bodleian Library, Oxford, Ouseley Add. 176, fol. 70a. The *Shahnama* of Firdawsi, with 47 miniatures (of which 4 are double-page compositions) and 5 tinted drawings; illumination signed by Nasr al-Sultani. The text includes Prince Baysunghur's preface (composed in 1426) and a dedication to Ibrahim Sultan, the Timurid viceroy of Shiraz who died in 1435. The miniatures in this manuscript are classic examples of the Shiraz style of the time—bold, vigorous, and with the figures represented confined to those essential to the narrative.

Plate 71. *Rustam and Suhrab*, ca. 1435-40. British Museum, London, No. 1948-10-9-51. One of several detached miniatures now in the British Museum from a fragmentary manuscript of the *Shahnama* of Firdawsi known as the "Manuk Shahnama" from its former owner. Other illustrations and part of the text are in the Fitzwilliam Museum, Cam-

bridge. The Timurid style of Shiraz, with its rugged vigor and comparative simplicity, was well suited to epic illustration.

Plate 72. *Princess Sarai Mulk Khanum Meeting Officers of the Army in Persia*, 1436. Seattle Art Museum, Washington. A detached miniature from a manuscript of the *Zafar Nama* ("Book of Victory") of Sharaf al-Din, the body of which, still containing 14 miniatures, is in the collections of the Kevorkian Foundation in New York. About the same number of miniatures, some of which are double-page compositions, are scattered in various collections, mostly American. The manuscript is dated 839/1436 by the copyist Ya'qub b. Hasan, and was probably executed for 'Abdallah, son and successor to Ibrahim Sultan as Governor of Shiraz. It was the latter who commissioned the writing of the *Zafar Nama*, a history of his formidable grandfather Timur, which was completed in 1425. This manuscript is clearly illustrated by some of the same artists who worked on Ibrahim Sultan's *Shahnama*. See note on Plate 70.

Plate 73. *Bahram Gur and the Dragon*, 1445. John Rylands Library, Manchester, England, MS Pers. 36. The *Khamsa* of Nizami, with 19 miniatures, dated 848–49/1444–45.

Since its earlier manifestations under princely patronage (Pls. 70, 72), the Shiraz-Timurid style had by this time settled down to the illustration of more modest manuscripts for patrons of less exalted standing. The present volume is an excellent example in fine condition; the miniatures appear to have been executed quickly, without much meticulous detail, but are nevertheless effective owing to the professional competence of the artist. What has been lost in rugged strength has been made up by naïve charm, and the vigor remains. Cf. Plate 26.

Plate 74. *The Court of Khan Kuyuk*, 1438. British Museum, London, No. 1948-12-11-05. This is one of several miniatures detached from a manuscript of the *Tarikh i Jahangushay* ("History of the World-Burner") of Juwayni, a chronicle of the Mongol conqueror

Chingiz Khan and his successors. Kuyuk was Chingiz Khan's grandson, and succeeded his father Ogotay as Great Khan in 1246. The fifteenth-century Persian artist has made no attempt to render the Mongol features or costumes, and the figures appear in the guise of his own contemporaries.

The body of the manuscript, with 6 miniatures, dated 841/1438, is in the Bibliothèque Nationale, Paris (Sup. pers. 206); copyist, Abu Ishaq b. Ahmad al-Sufi of Samarqand.

Plate 75. *Layla and Majnun in Paradise*, 1450. Metropolitan Museum of Art, New York, No. 13.228.3, fol. 181b. The *Khamsa* of Nizami, with 31 miniatures, dated 854/1450. Apart from a few at the beginning, the miniatures in this copy of the *Khamsa* are clearly by the same hand as those in the Manchester volume (see Pl. 73).

Plate 76. *Combat of Bizhan and Farud*, ca. 1440. Metropolitan Museum of Art, New York, No. 20.122.47. This is a detached miniature (one of a dozen in the same museum) from another mysterious *Shahnama* which we class as "provincial" for want of a better pigeonhole. Another miniature from the same set has been cut in two and is shared between the British Museum, London (No. 1948-12-11-04), and the Museum of Fine Arts, Boston (No. 14.544). Though roughly contemporary, the style is quite different from that of the preceding plate; the rough strength and large figures may perhaps indicate a northern origin. Unfortunately, when these manuscripts were broken up by dealers and their miniatures sold separately, perhaps fifty or sixty years ago, the colophons, which might have provided valuable information, were not thought worth preserving.

Plate 77. *Shirin Visiting Farhad at Mount Behistun*, 1481. The Chester Beatty Library, Dublin, Pers. 162, fol. 73a. The *Khamsa* of Nizami, with 25 miniatures, dated 886/1481; copyist, Murshid. The style of these miniatures (apart from five of them, which are in the Turkman style) has the same general characteristics as those of the Isfahan Nizami

(preceding Plate). They were certainly painted at Shiraz (Murshid was a well-known Shiraz scribe, and sometimes added "at Shiraz" to his colophons) and exemplify the delicate southern provincial style that was practiced alongside the Turkman style at that city and at Isfahan until about 1485.

Plate 78. *The Birth of Rustam, ca.* 1450. Private Collection, London. Detached miniature from a manuscript of the *Shahnama* of Firdawsi; several other leaves from this strange volume are in private possession in America, one is in the Ashmolean Museum at Oxford, and one is in the India Office Library, London. Their style has perhaps more in common with that of Shiraz than with any other, which would incline one to place them in the south rather than the north of Persia. But at the back of our minds we must keep the possibility that some of these more problematical works of the Timurid period may have been executed (probably by Persian artists) at one or another of the contemporary Muslim courts of India. The painting of Muslim India before the Mughal period is still *terra paene incognita*. Apart from the style of the paintings, another unusual feature is that the text is written in six columns instead of the normal four.

Plate 79. *Majnun Expiring on Layla's Tomb,* 1463. The Chester Beatty Library, Dublin, Pers. 137, fol. 131b. The *Khamsa* of Nizami, with 23 miniatures, said to have been dated 868/1463 by the copyist Darwish 'Abdallah "at Isfahan" (the colophon has been lost). The miniatures are highly individual in style, but display the light touch and a number of details that can be associated with southern and southwestern Persia. Although almost in the middle of the country, Isfahan seems always to have had closer links with its southern neighbor Shiraz than with the northern centers, and the traditional Isfahani origin of this manuscript may be accepted.

Plate 80. *Prince and Attendants in a Garden,* 1478. The Chester Beatty Library, Dublin, Turk. 401, fol. 8b. The *Diwan* of Hidayat-allah written in Azarbayjan Turkish, with 4 miniatures. Its date may be fixed at 1478 by its dedication to the "White Sheep" Turkman Sultan Khalil, whose reign only lasted six months, and the central figure in this miniature is no doubt intended to represent him.

The squat figures with rather large heads are characteristic of the Turkman style, but the execution and meticulous detail are here much finer than we find in the more routine examples of the style produced at Shiraz a decade or more later (Pls. 81, 83, 84, 86).

Plate 81. *The Concourse of Birds,* 1493. Bodleian Library, Oxford, Elliot 246, fol. 25b. The *Mantiq al-Tayr* ("Language of Birds"—cf. note on Pl. 27) of Farid al-Din 'Attar, with 7 miniatures in the Turkman style, dated 898/1493; copyist, Na'im al-Din of Shiraz. This is a mystical poem describing—by an allegory of the Birds' searching for the Simurgh, a kind of phoenix (cf. Pl. 52)—the search of Man for God.

The preliminary meeting of the Birds to discuss their plans is here depicted, but the artist has included the Simurgh itself in the group.

Plate 82. *Two Men Greeting a Youth on a Balcony, ca.* 1500. The Chester Beatty Library, Dublin, Pers. 233, fol. 131a. The *Diwan* of Amir Khusraw, with 10 miniatures; copyist, Sultan 'Ali of Mashhad (but this may be a false attribution). This miniature, which is vastly superior to the others in the volume, exemplifies (like Pl. 80) the more refined form of the Turkman style.

Plate 83. *Mir Sayyaf Cuts off the Arm of the King of the East,* 1477. The Chester Beatty Library, Dublin, Pers. 293, No. 2. A detached miniature (one of ten in the Chester Beatty Library) from a manuscript of the *Khawar Nama* of Ibn Husam, the text dated 854/1450. The manuscript originally contained 154 miniatures; many of them have been detached and are scattered in various collections, and the residue, together with the body of the manuscript, are in the Museum of Decorative Arts, Tehran. Several (including this one) bear the signature of the otherwise unknown artist Farhad, with the date 881/1476. The *Khawar Nama* is an epic, composed in 1427, which describes the exploits—largely mythical—of 'Ali and other early champions of Islam against a variety of infidels, monsters, and demons.

Plate 84. *Rustam Dragging the Khaqan from His White Elephant,* 1486. British Museum, London, Add. 18188, fol. 160a. The *Shahnama* of Firdawsi, with 72 miniatures, dated 891/1486; copyist, Ghiyath al-Din b. Bayazid. Fourteen of the miniatures in this manuscript are in a very individual southern provincial style, while the remainder are excellent examples of the Turkman style.

Plate 85. *Khusraw and the Lion, ca.* 1505–10. India Office Library, London, Pers. MS 387, fol. 65b. The *Khamsa* of Nizami, with 48 miniatures. Cf. Plate 58.

The bulk of the miniatures are exquisite and rather unconventional examples of the Turkman style, obviously the work of an artist of great skill and originality; some in the latter part of the volume, however, though quite possibly by the same hand, are experiments with the newly developing style of Tabriz. The similarities in many of them to the early work of Sultan Muhammad in the Rothschild *Shahnama* (cf. note on Pl. 32) are very striking.

Plate 86. *Presentation of the* Shahnama *to Prince Baysunghur,* 1494. Bodleian Library, Oxford, Elliot 325, fol. 7a. The *Shahnama* of Firdawsi, with 55 miniatures in the Turkman style, dated 899/1494; copyist, Sultan Ilusayn b. Sultan 'Ali b. Aslanshah.

The manuscripts from which Plates 81, 83, 84, and 86 are reproduced are all illustrated in the "routine" Turkman style, centered at Shiraz. This city had evidently become a sort of emporium producing illustrated manuscripts of rather less than the first quality, probably on a commercial scale (nearly fifty such manuscripts are known from the period 1475–1510)—a role she seems to have begun under the Timurid rulers (see

note on Pl. 73) and which, as we shall see, she continued under the Safawids.

Plate 87. *The Speech of the Rose*, 1504–5. University Library, Uppsala, Sweden, No. CLXXI, fol. 43a. *Dastan i Jamal u Jalal* of Asafi, with 34 miniatures dated 909/1504 (fol. 35b) and 910/1505 (fol. 57b); the text, copied by Sultan 'Ali "at Herat," is dated 908/1502–3. The miniatures in this unique manuscript are examples of the Turkman style in its later stages and quite unlike the contemporary style of Herat where the text was copied. But as they were added one or two years later this need not perplex us unduly. The appearance of the Safawid "baton" on the turbans is alone sufficient to disprove a Herat attribution; Herat did not come under Safawid rule until after the defeat of Shaybani Khan by Shah Isma'il I in 1510.

Asafi, a pupil of the poet Jami, was one of the brilliant circle gathered around Sultan Husayn Mirza at Herat at the end of the fifteenth century. His poem is the love story of Prince Jalal and Jamal, daughter of a fairy king, in the course of which the former is addressed by various flowers in the garden.

Plate 88. *Iskandar Entertaining the Khaqan, ca.* 1520. Collection of Dr. and Mrs. Schott, Gerrards Cross, England (Formerly Paul Loewi Collection). The *Khamsa* of Nizami, with 14 miniatures, fol. 287a. Traces of the Turkman style in Shiraz painting had almost all disappeared by this date, although occasional freak survivals are encountered as late as the middle of the century (e.g., Chester Beatty Library, Dublin, Pers. 214, dated 955/1548).

Plate 89. *Combat of Rustam and Isfandiyar,* 1560. India Office Library, Pers. MS 133, fol. 321b. The *Shahnama* of Firdawsi, with 24 miniatures, dated 967/1560; copyist, Hasan b. Muhammad Ahsan "at Shiraz." This is another work by the same artist as *Timur Enthroned* (Pl. 91); he contributed about half the miniatures to this fine copy of the *Shahnama*.

Plate 90. *The Qazi and the Farrier's Daughter,* 1513. British Museum, London, Or. 11847, fol. 73b. The *Gulistan* of Sa'di (see note on Pl. 14), with 13 miniatures, dated 919/1513; copyist, Mun'im al-Din al-Awhadi al-Husayni. A *qazi,* or judge, became besotted with the rather flighty daughter of a farrier, and embarked on a life of notorious dissipation. The king, scandalized, ordered him to be thrown from the roof of the castle, but the *qazi* implored that somebody else should be thrown down, so that he might benefit from the example and mend his ways. The king laughed and spared him.

The miniatures in this manuscript clearly illustrate how the Safawid style of Shiraz grew out of the Turkman style of the previous century.

Plate 91. *Timur Enthroned,* 1552. British Museum, London, Or. 1359, fol. 35b. The *Zafar Nama* of Sharaf al-Din (see note on Pl. 72), with 12 miniatures, dated 959/1552; copyists, Murshid al-'Attar and Hasan al-Sharif. This is a manuscript of outstanding quality which, though not to be compared with contemporary "royal" volumes such as the Freer Jami (Pls. 45, 48), is well above the normal level of Shiraz work. Most of the miniatures are by an artist—unfortunately anonymous—whose distinguished work can be recognized in a number of Shiraz manuscripts between about 1540 and 1560.

Plate 92. *Rustam and the White Demon, ca.* 1580. India Office Library, London, Pers. MS 741, fol. 94b. The *Shahnama* of Firdawsi in two volumes, with 14 miniatures (some of them, alas, repainted in India); copyist, Hidayat-allah of Shiraz.

The illustrator of this manuscript, again anonymous, was another outstanding figure in Shiraz painting. This is a large *Shahnama,* like many other copies produced at Shiraz in the later sixteenth century, but the artist seems to have enjoyed having so much space to fill; his broad compositions are crowded with incident and detail, and his drawing and execution are of very high quality.

Plate 93. *Gayumarth, the First King, and His Court, ca.* 1590. India Office Library, London, Pers. MS 3540, fol. 18a. The *Shahnama* of Firdawsi, with 59 miniatures, formerly the property of Warren Hastings (d. 1818). This large and sumptuous manuscript is illustrated by a competent but comparatively undistinguished artist who allowed his work to deteriorate somewhat towards the end of the volume. In this, the first miniature in the book, however, he has achieved a careful and effective rendering of this favorite subject.

Plate 94. *The King and the Robbers,* 1554. Bibliothèque Nationale, Paris, Sup. pers. 1958, fol. 9b. The *Gulistan* of Sa'di (see note on Pl. 14), with 5 miniatures, one of which is dated 961/1554; the text dated 950/1543; copyist, Mir 'Ali of Mashhad. The story is of a vizier who begs for the life of a youthful bandit about to be executed with the rest of the captured gang. The king grants it, but the youth reverts to type, murders and robs the vizier and his family, and is soon leading a gang of his own. "How can anyone form a sword out of bad iron?" is the king's comment.

By the middle of the century the Bukhara style had begun to decline, but occasionally, as here, the earlier precision of drawing and richness of color are recaptured.

Plate 95. *Equestrian Sports,* 1775. Victoria and Albert Museum, London, No. 763–1888. During the eighteenth century the art of book-illustration was in abeyance; Persian artists turned to the decoration of papier-mâché pen boxes, mirror cases, and book covers, and, increasingly, to large portraits and groups in oils. Aqa Sadiq, whose signature appears on this mirror case with the date 1189/1775, was the leading Persian artist of the period, his greatest work being the huge fresco in the Chehel Situn Pavilion, Isfahan, representing the victory of Nadir Shah over the army of the Mughal Emperor Muhammad Shah at the Battle of Karnal in 1738.

Plate 96. *The Marriage of Mihr and Nahid,* 1523. Smithsonian Institution, Freer Gallery of Art, Washington, D.C., No. 32.8. Detached miniature from a manuscript of the *Mihr and Mushtari* ("The Sun and Jupiter") of 'Assar, dated 929/1523; copyist, Ibrahim Khalil "at Bukhara." This romantic poem describes the adventures of Mihr and his reception at the court of King Kaywan of Khwarazm, where he fell in love with Nahid, the king's daughter; after leading the king's army to victory over the Tartars he eventually married her. At this early stage the work of the Bukhara school is almost indistinguishable from that of the school of Bihzad at Herat.

Plate 97. *Head of Khusraw Khan Kirmani, ca.* 1850–60. British Museum, London, Or. 4938, No. 12. This excellent portrait is by Abu'l-Hasan Ghaffari, known as Sani' al-Mulk, or (Chief) Painter of the Kingdom, who was the ablest Persian artist during the long reign of Nasr al-Din Shah. He executed a considerable number of portraits similar to this one, most of which were preliminary studies for a great wall painting in seven panels, representing Nasr al-Din enthroned with his court, and containing over one hundred life-size figures. This is now in the Archaeological Museum in Tehran, together with a number of the portrait studies. His other great work for the king was the illustration of a huge six-volume manuscript of the *Arabian Nights* in 1853, illustrated with hundreds of miniatures of splendid quality; this is now in the Gulistan Palace Library, Tehran. He died in 1866, aged 54.

Plate 98. *Fath 'Ali Shah Hunting with His Family, ca.* 1825. British Museum, London, Or. 2265, front cover. This celebrated manuscript (see note on Pl. 35) was evidently in need of repair about a hundred and fifty years ago, and Fath 'Ali Shah ordered new covers of painted and lacquered papier-mâché. These have been removed from the volume and are now kept separately mounted at the British Museum. The front cover, shown here, is signed by Sayyid Mirza, a prominent court artist during the latter part of Fath 'Ali Shah's reign (the other is signed by Muhammad Baqir). He worked mainly in oils, but the grace and delicacy of this book cover place him in the front rank of miniature painters of this period.

Plate 99. *Rose and Nightingale,* 1803. The Chester Beatty Library, Dublin, Mugh. 31, cover. This exquisite version of a traditional Persian book-cover design, in painted lacquer on papier-mâché, is signed by Mihr 'Ali and dated 1218/1803. He was one of the most distinguished court artists during the earlier part of Fath 'Ali Shah's reign (fl. 1800–1815). His most important works are six superb life-size oil portraits of his royal master, dated between 1802 and 1813, of which two are in the Gulistan Palace, Tehran, two in The Hermitage, Leningrad, and two in private collections in London.

Plate 100. *Portrait of Prince 'Ali Quli Mirza,* 1863. British Museum, London, Or. 4938, No. 6. This prince was Minister of Education, Commerce, and Industry under Nasr al-Din Shah, and enjoyed the title of I'tisad al-Sultana ("Support of the Monarchy"). The artist, Yusuf, is otherwise unknown, but seems to have been a pupil of Sani' al-Mulk (Pl. 92), the present portrait being derived from an original by him.

Bibliography

NOTE: For a comprehensive bibliography of the subject, see Professor K. A. C. Creswell's *A Bibliography of the Architecture, Arts and Crafts of Islam to 1960*. Oxford, 1961 (columns 979-1094).

GENERAL

Arnold, Sir Thomas. *Painting in Islam*. Oxford, 1928 (a reprint by Dover Publications, New York, is in preparation).

Arnold, Sir Thomas, and Grohmann, Adolf. *The Islamic Book*. Paris, 1929.

Barrett, Douglas. *Persian Painting of the Fourteenth Century*. London: The Faber Gallery of Oriental Art, 1952.

Binyon, Laurence; Wilkinson, J. V. S.; and Gray, Basil. *Persian Miniature Painting*. London, 1933.

Blochet, Edgard. *Musulman Painting*. London, 1929.

Gray, Basil. *Persian Painting*. Skira (Treasures of Asia), 1961.

Guest, Grace Dunham. *Shiraz Painting in the Sixteenth Century*. Washington, D.C.: Freer Gallery of Art (Oriental Studies No. 4), 1949.

Huart, C. *Les Calligraphes et les Miniaturistes de l'Orient musulman*. Paris, 1908.

Kuehnel, Ernst. *Miniaturmalerei im islamischen Orient*. Berlin, 1922.

Marteau, Georges, and Vever, Henri. *Miniatures persanes exposées au Musée des Arts décoratifs*. 2 vols. Paris, 1913.

Martin, F. R. *The Miniature Painting and Painters of Persia, India, and Turkey*. 2 vols. London, 1912.

Pinder-Wilson, Ralph. *Persian Painting of the Fifteenth Century*. London: The Faber Gallery of Oriental Art, 1958.

Pope, Arthur Upham (ed.). *A Survey of Persian Art*. Oxford, 1939. See especially the section by Ernst Kuehnel on book painting (Vol. III, pp. 1829-1897 and plates 812-925).

Sakisian, Armenag Bey. *La Miniature persane du XIIe au XVIIe siècle*. Paris and Brussels, 1929.

Schulz, Philipp Walther. *Die persisch-islamische Miniaturmalerei*. 2 vols. Leipzig, 1914.

Stchoukine, Ivan. *La Peinture iranienne sous les derniers 'Abbasides et les Il-Khans*. Bruges, 1936.

Stchoukine, Ivan. *Les Peintures des Manuscrits Timurides*. Paris, 1954.

Stchoukine, Ivan. *Les Peintures des Manuscrits Safavis de 1502 à 1587*. Paris, 1959.

Stchoukine, Ivan. *Les Peintures des Manuscrits de Shah 'Abbas Ier à la fin des Safavis*. Paris, 1964.

WORKS ON PARTICULAR COLLECTIONS

Blochet, Edgard. *Les Enluminures des Manuscrits orientaux de la Bibliothèque Nationale*. Paris, 1926.

Blochet, Edgard, *et al. The Chester Beatty Library: A Catalogue of the Persian Manuscripts and Miniatures*. 3 vols. Dublin, 1959–1962.

Coomaraswamy, Ananda K. *Les Miniatures orientales de la Collection Goloubew au Museum of Fine Arts de Boston*. (Ars Asiatica XIII.) Paris and Brussels, 1929.

Robinson, B. W. *A Descriptive Catalogue of the Persian Paintings in the Bodleian Library*. Oxford, 1958.

Schroeder, Eric. *Persian Miniatures in the Fogg Museum of Art*. Cambridge, Mass., 1942.

WORKS ON PARTICULAR MANUSCRIPTS

Arnold, Sir Thomas. *Bihzad and his paintings in the Zafar-Namah MS*. London, 1930.

Binyon, Laurence. *The Poems of Nizami*. London, 1928.

Martin, F. R. *Les Miniatures de Behzad dans un Manuscrit persan daté 1485*. Munich, 1912.

Martin, F. R. *Miniatures from the Period of Timur in a MS of the Poems of Sultan Ahmad Jalair*. Vienna, 1926.

Martin, F. R. *The Nizami MS from the Library of the Shah of Persia now in the Metropolitan Museum at New York*. Vienna, 1927.

Martin, F. R., and Arnold, Sir Thomas. *The Nizami MS Or. 6810 in the British Museum*. Vienna, 1926.

Wilkinson, J. V. S. *The Shah-Namah of Firdausi*. Oxford, 1931.

Zettersteen, K. V., and Lamm, C. J. *Mohammed Asafi: the Story of Jamal and Jalal*. Upsala, 1948.